URBAN LEGENDS &
HISTORIC LORE OF
WASHINGTON, D.C.

ROBERT S. POHL

Charleston London

THE
History
PRESS

Published by The History Press
Charleston, SC 29403
www.historypress.net

First published 2013

Manufactured in the United States

ISBN 978.1.62619.196.9

Library of Congress CIP data applied for.

Contents

Foreword

G reat cities make great stories. It's a fact that might seem implicit in
the term "urban legend," but it arguably goes deeper than that. We
tend to make stories about important places, where the players are a little
bigger and the stakes a little more consequential. Washington, D.C., is a
city consequential by design, not by some accident of geography or history.
Its monuments, its institutions, the very plan of its streets were all intended
to tell stories about the nation that built it. Little surprise, then, that on its
journey through time, Washington has acquired a barnacle-like profusion of
urban legends.

Robert Pohl is our kind of debunker. Anyone who knows him or has
accompanied him on one of his walking tours of his adopted city values
his passion for his subject, his fine-grained knowledge and, perhaps most
important in this case, his sense of humor. I thought I knew a thing or two
about Washington when I picked up this book. My actual knowledge, alas,
turned out to be a lot thinner than I thought. Pohl doesn't just correct these
impressions; he shows us that the truth is often more fascinating—and
instructive—than the legend.

Of course, books like this are bound to fail when it counts most. This
is because the most popular, persistent urban legends are, to paraphrase
Claude Levi-Strauss, "so good to think" that they have graduated beyond
mere falsehood into the realm of myth. Myths are not about what happened
or what we think happened but what we collectively need to have happened.
As Pohl argued, George Washington very likely did not sleep in the various

places around the capital where he is said to have slept. But insofar as the city needs be "sanctified" by the presence of its namesake, if only briefly, the stories will persist.

Armed only with his facts and his enthusiasm, Pohl is mismatched against the challenge he sets himself. But it's fascinating to see him try.

—Nicholas Nicastro

Acknowledgements

I first became aware of urban legends when a friend in college, Mike Hopcroft, explained that there was a whole class of stories told as truth but that were, in fact, the modern equivalent of the Grimm fairy tales that I knew from my childhood.

I began reading more about them in 1992 when I signed up to the usenet newsgroup alt.folklore.urban, and this gave me an insight into the range and history of these stories. Through the newsgroup, I was also exposed to the work of Jan Harold Brunvand, Cecil Adams and William Poundstone, each of whom has made valiant attempts to rid the world of misinformation. Two of those whom I first encountered on AFU (as it was generally referred to among its readers) were Barbara and David Mikkelson, who have since founded the extremely popular urban legends website Snopes.com, an important resource for anyone confronted with a dubious story, e-mail forward or statistic. I am deeply indebted to their website as a source in writing this book, as I am to Cecil Adams's website, StraightDope.com.

In my previous book, I wrote about the death of Representative Taulbee and the stories that grew out of that tragic tale. As I delved into old newspapers to determine what had really happened, I began to realize that the story had become an urban legend, that although the main facts were true, it had slowly evolved into a tale with a distinct moral, in that the death was, in a way, retribution for having taken up with a young woman not his wife, having first his career ruined and then losing his life.

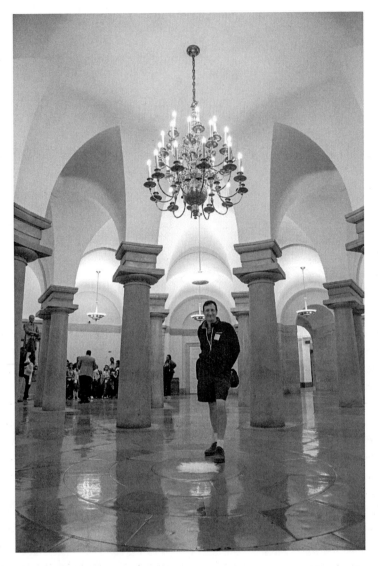

The author standing in the crypt of the Capitol, next to the star where President George Washington was to be buried. *Photo by Maria Helena Carey.*

As a tour guide, I have discovered that the best way to keep an audience engaged is to tell stories. They will not remember names and dates—I can barely do that, and I get paid to do so—but stories make it easier to remember the importance of the many buildings, memorials and monuments that we pass. Thus, I was thrilled to read about the fact that women were not allowed

into the elevator in the Washington Monument when it opened. This was a perfect object lesson in that it both soundly rebuked the attitudes men had toward women in the late nineteenth century and made the dry facts of the monument and its elevators come alive. I was crushed when told by Tim Krepp, a fellow tour guide and the one who convinced me that becoming one would be a good career move, that there was no truth whatsoever in the story.

The next story that presented itself was that of the keeper of the crypt. Here again, a fairly straightforward attempt by a congressman to save the government some money had morphed into a disquisition on the spendthrift nature of government, a charge that many people in this country are more than happy to level at those in power.

In short, I became aware that there were dozens of these stories around, some told by tour guides every day, some well known to be false and some falling in both these categories. What particularly intrigued me was the fact that the real story was often more interesting (if less morally charged) than the story as told.

In the writing of this book, I have had the help of numerous people and organizations: the above-mentioned Tim Krepp, especially for his close reading of the manuscript; Professor Roger Giner-Sorolla, who pointed me toward a few articles by psychologists writing about urban legends; fellow authors Garrett Peck and John DeFerrari; photographer Carol Highsmith, who not only took a huge number of remarkable photos all across the country and gave them to the Library of Congress for use by anybody but also immediately replied to my query about my use of them; Professors Gary Alan Fine and Barry O'Neill, who took time out of their busy schedules to answer questions about the infamous Cabbage Seed Memo; and, of course, anyone who has told me a new story—or simply a new version thereof.

Thanks also go to the good people in the Washingtoniana Collection of the DC Public Library who helped me find all sorts of obscure references. Similarly, the Virginia Room at the Arlington County Library helped me nail down the legend of the thirteenth hand on the Iwo Jima Memorial. Thanks are also due to everyone at my second home: the Southeast Branch of the DC library. And, of course, the morning crew at Peregrine Espresso.

As always, any mistakes are purely my own. I have attempted in every case to get as close to a primary source as possible, but sometimes this is not possible, and even when available, I have come to the realization that these are faulty at times, and thus some "facts" may be nothing of the sort but are rather either my misinterpretation or a failure to separate fact from fiction.

And finally, no acknowledgment would be complete without thanking my family: Antonia Herzog, my long-suffering wife (who has forbidden me to tell the story of the keeper of the crypt ever again), and son Ian, who simply wonders why I spend so much time at the computer. Thanks, everyone, I could not have done it without you.

Introduction

*I will set down a tale as it was told to me by one who had it of his father,
which latter had it of his father, this last having in like manner had it of his
father—and so on, back and still back, three hundred years and more, the fathers
transmitting it to the sons and so preserving it. It may be history, it may be only a
legend, a tradition. It may have happened, it may not have happened: but it could
have happened. It may be that the wise and the learned believed it in the old days;
it may be that only the unlearned and the simple loved it and credited it.*
—*Mark Twain,* The Prince and the Pauper

You've all heard the stories. The guy who wakes up the morning after a
drunken evening in a bathtub filled with ice and missing a kidney. The
driver who picks up a female hitchhiker who disappears before arriving at
her home—where her parents tell the driver that she died a year ago. The
expensive sports car being sold for cheap as revenge by a cuckolded and
abandoned wife.

These stories have a number of things in common: they are told as
true, they have a visceral impact and they have little if no basis in reality.
They never happened to the teller or even a friend of the teller but rather
to a friend of a friend of the teller. They are stories that are too good to
be true—for good reason, as they are not, in fact, true. They exist at the
intersection of jokes, horror stories and morality tales. Their power comes
both from their supposed truth as well as their apparent moral. They
are urban legends and as such have been studied for years by folklore

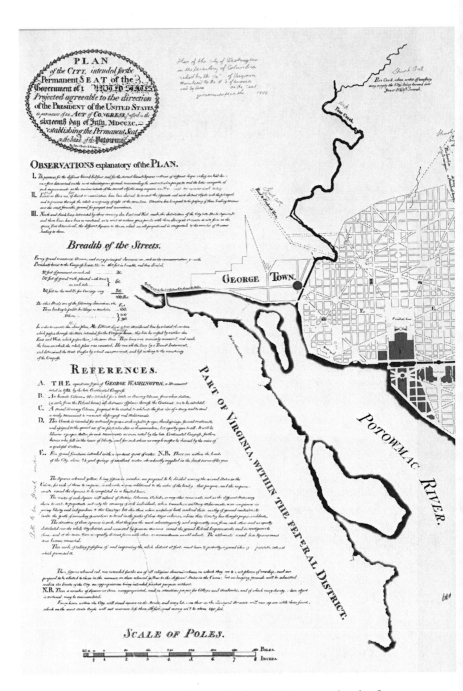

A computer-assisted reproduction of Peter L'Enfant's 1791 manuscript plan for the city of Washington. *Library of Congress.*

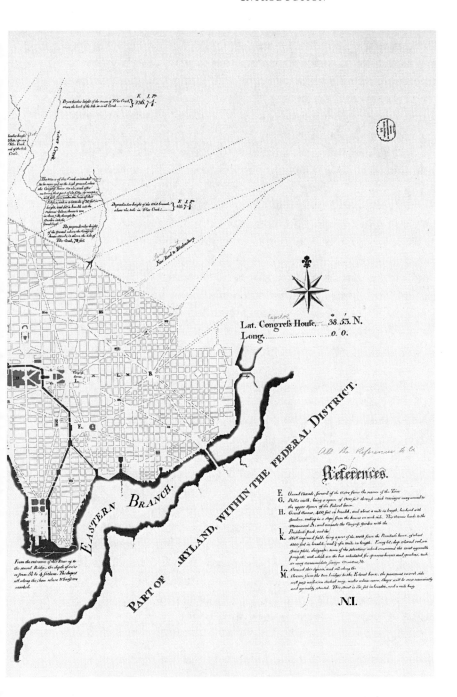

researchers who have used them to divine insights into the psyches of those who tell them, as well as the societies in which they flourish.

One of the groups that study these tales is an Internet newsgroup called alt.folklore.urban, consisting of laypeople from all walks of life intrigued by these stories. These people have spent years collecting, analyzing and debunking urban legends. Along the way, they have written up a long list of legends, including the truth or falsity (when they can be determined) of the legends. In this list is also included their definition of an urban legend, which, according to them, "appears mysteriously and spreads spontaneously in varying forms, contains elements of humor or horror (the horror often 'punishes' someone who flouts society's conventions), makes good storytelling and does NOT have to be false, although most are. Urban legends often have a basis in fact, but it's their life after the fact (particularly in reference to the second and third points) that gives them particular interest."

The stories in this collection are a bit different because most of them do have a basis in fact. They do, however, share certain characteristics of urban legends: their story quality, the oral transmission, their humor and, above all, the fact that they exist in many variants. This last fact is directly connected with all the others.

Every year, millions of visitors descend on Washington, D.C., to see the sights, learn about the government of the United States and engage with the history of the country. A large industry has sprung up around this influx, with hundreds of tour guides engaged in giving the tourists the maximum information in the short time most have allocated to exploring all these aspects of the city.

Tour guides have long ago learned (probably while they were faced with learning American history in the eighth grade) that names, dates and facts are boring beyond belief, and soon after beginning their work, they have begun to see those facts flying back out of their charges' ears almost immediately upon them entering. In short, some other way of transmitting information is needed. And the best possible way to deliver these facts is through stories. Instead of telling dry dates and names, wrapping them in an interesting story will help keep the listeners engaged and make them more likely to remember some of what they heard in the course of their tour.

Opposite, top: Aerial view of the National Mall, including the Capitol, Library of Congress, Supreme Court and Washington Monument. *Historic American Buildings Survey Collection, Library of Congress.*

Opposite, bottom: Aerial view of the White House in the snow, 1934. *Harris & Ewing Collection, Library of Congress.*

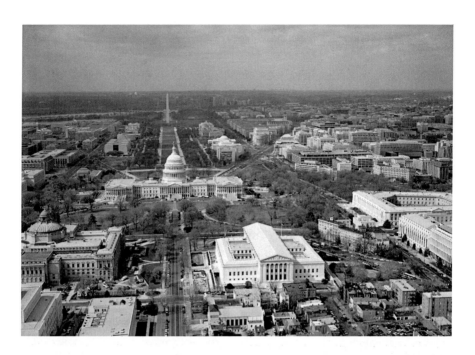

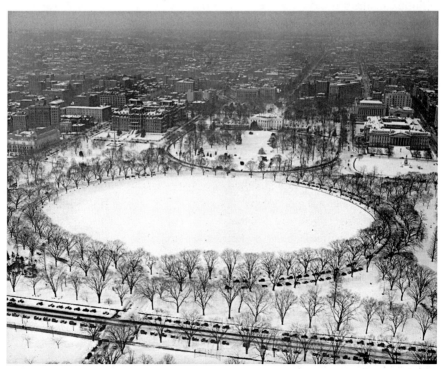

As noted security expert Bruce Schneier wrote in a completely different context, "We humans are natural storytellers, and the world of stories is much more tidy, predictable and coherent than the real world."

Thus, it behooves the tour guide to learn the stories related to the city, possibly changing a detail or two to make them more palatable, and to pass them on with the certitude brought on by long practice. If a story thus gains a moral, all the better. While the moral in a true urban legend tends to be directed against flouting society's conventions, there is no single motive in the morals here, though in quite a number the anti-government nature of the story is fairly obvious.

Over time, in contrast to Oliver Wendell Holmes's assertion that "the best test of truth is the power of the thought to get itself accepted in the competition of the market," changes made to the story tend to make it more powerful, either by the addition (or clarification) of a moral or by making the tale more shocking or simply by making it a better story. Studies done by psychologists show that the most widely disseminated versions of urban legends tend to be the most extreme variants or the most entertaining, and these "entertain or keep the listener's attention, thereby enhancing social relationships."

In short, it might be more appropriate to call these Tour Guide Tales, as their primary function has been to help tell the stories of the history, buildings and memorials in Washington, D.C. In the following pages, thirty-three of the best-known tales will be cited, along with a discussion about the real truth behind them.

CHAPTER 1

Building the New Capital

Washington, D.C., is different from most cities in the United States in that it was designed from the ground up. Thus, there is no "old section" of town with crooked streets and narrow sidewalks. When Peter L'Enfant began the job of surveying the land selected by George Washington for the new federal capital and laying out streets and avenues that would be used ten years later, he was operating with an almost completely blank slate.

Over the years, numerous tales have sprung up about the initial design of the city. A selection follows.

NO DUST, NO ROCKS

I'm always happy to be away from Washington, D.C.—a town all too clearly built on a swamp and in so many ways still a swamp.
—Robert Gates, August 31, 2010

Secretary of Defense Robert Gates's introductory words in a speech to an American Legion post make for an amusing, self-deprecatory remark. After spending most of his career in and around Washington, D.C., for him to complain about the swamp-like nature is, indeed, ironic. It is also wrong.

The geography of the land on which Washington, D.C., was built is varied, from riverfront mudflats to highlands, but there is very little that could be considered a swamp. In fact, most of the land had been previously used as farmland or pasture, neither of which would be possible had the land truly been a swamp. Don Hawkins, an architect and cartographer who knows more about what the land Washington was built on looked like before the federal government moved there in 1800, says that less than 1 percent of the land was swamp at the time. He should know; he spent three decades researching the topic, crowning his work with a topographic map that shows every little wrinkle in the land in 1791, when Peter L'Enfant, a French-born soldier and civil engineer who served under George Washington, came to Georgetown to begin his work.

Bob Arnebeck, who researched the changes wrought on the federal district before the arrival of the government in 1800, comes to a similar conclusion. He, however, points out that the unfinished nature of the city in the early decades of the nineteenth century meant that there were many places in the city that resembled a swamp—particularly in contrast to the buildings going up on either end of Pennsylvania Avenue. Even areas that had originally been cleared for building had been overgrown with second-growth trees and other undesirable plants. In short, Arnebeck concludes, "To the extent that the word swamp is a synonym for underdevelopment, Washington was very much a swamp."

Many sources quote an unnamed official as writing, in the early part of the nineteenth century, that D.C. was a "mud-hole almost equal to the great Serbonian bog," though this turn of phrase does not appear until late in the nineteenth century—without anyone giving a source. In any case, this is more likely to refer to Arnebeck's definition of swamp than a true swamp. The phrase, if actually uttered, was more likely to refer to the consistency of the mud on Pennsylvania Avenue than to the state of the federal district when L'Enfant laid it out.

Added to this, 1 percent of the city is sixty-four acres—not an inconsiderable amount. These swampy acres were spread around the city, mainly along the riverfronts of the Potomac and Anacostia Rivers. The Potomac is tidal, which means that the river rises and falls along with the tides in the Chesapeake Bay, leaving, at low tide, mud flats all along the river. They can be seen, for instance, around Roosevelt Island, across from the Kennedy Center. While at high tide, the island and its verdant green forest descends directly to the waters of the river; at low tide, it is surrounded by mud flats that would make for extremely uncomfortable crossings.

The Lincoln Memorial under construction. *National Photo Company Collection, Library of Congress.*

Another swampy area was Swampoodle, an Irish neighborhood just north of Union Station. Known as a tough place that even D.C.'s police force hated to visit, it was crammed with immigrants fleeing the Irish potato famine. The Tiber Creek ran through it and thus made for a particularly insalubrious climate, with diseases such as typhoid fever and malaria running rampant.

Other swampy areas were created along the way. Joe Cannon famously referred to the area on which the Lincoln Memorial was to be built as a "god-damned swamp." In this case, however, the land had been created by dredging the Potomac and dumping the fill along its banks. The land thus created was indeed originally quite wet, but again, this was not the swamp on which D.C. was supposedly built.

A related legend has it that the new capital city of the United States was such an unpleasant place that it was, for British diplomats, a hardship post. John Kelly, *Washington Post* reporter, contacted historians at the British Foreign and Commonwealth office who confirmed that that "[i]n 1907... Washington was not on Her Majesty's list of 'unhealthy places,'" nor was

it found in any of the other lists of this nature in previous years that they looked at.

If you do want to see a swamp in the District today, your best bet is Kenilworth Aquatic Gardens, a park run by the National Park Service located along the Anacostia River a few miles upstream of its confluence with the Potomac. Along with the ponds built over one hundred years ago to grow water lilies are wetlands that defined the shores of the rivers before they were turned into the carefully graded riverfronts that we know today.

On the other hand, if you wish to see what most of the District looked like when Peter L'Enfant surveyed the city, head over to Congressional Cemetery in the southeast quadrant of the city, on the banks of the Anacostia. Its gently rolling hills have been untouched and ungraded since the birth of the city.

THE OLD STONE HOUSE

Gen. George Washington's Headquarters while Surveying the City of Washington, D.C., in 1791.
—caption on an early twentieth-century postcard showing the structure now known as the Old Stone House on M Street in Georgetown

"George Washington Slept Here" is a cliché in historical circles, an excuse to charge more for a bed-and-breakfast and even a (poorly received) 1942 movie. Nonetheless, it lives on as a testimony to the pull that the father of his country has on the citizens thereof, even two-hundred-plus years after his death. It is thus hardly surprising that some locations become intertwined with his name even long after it has been conclusively proven that he had no connection to them.

In some cases, this has some (eventual) positive outcome in that houses that might otherwise not be saved are shielded from the attention of a wrecking ball. One of these places is a small house located on bustling M Street in the middle of Georgetown, the D.C. neighborhood that predates the city by some fifty years. Known as the Old Stone House, it is today run by the National Park Service, and it serves as a reminder of what Georgetown was like before the District of Columbia was even a figment of anyone's imagination.

The Old Stone House was most likely built in 1765 by Christopher Layman (or Leyhman). Layman was a carpenter and thus built the house

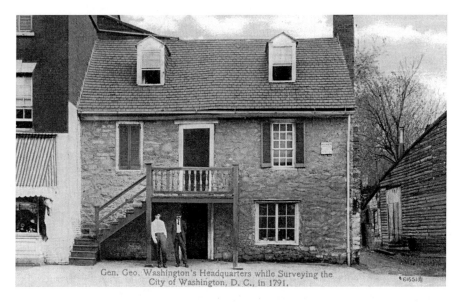

A postcard showing the Old Stone House in the early twentieth century. *Courtesy of John deFerrari.*

for both his shop and residence. Sadly, he did not live to enjoy his new house for long, and his widow (who quickly remarried) sold the house to Cassandra Chew in 1767. Chew was allied with local businessman Robert Peter (some sources list her as his wife, others as his mistress), and they had two daughters. Mary Smith, née Chew (although she sometimes also used Peter as her last name), lived in the Old Stone House, renting out rooms in it to supplement her income. One of the renters was a young man named John Suter Jr., who moved in around 1800 and later became an owner by dint of marrying Smith's daughter Barbara. It is Suter's connection to the building on which the whole connection to George Washington rests.

In the early 1790s, important people coming to Georgetown had one place to stay: the Fountain Inn. Run by John Suter and usually known by the name of its proprietor, its important guests included Peter L'Enfant, Thomas Jefferson—and George Washington. Jefferson even wrote about the excellence of Suter's food and drink. There were, of course, other taverns in Georgetown, but most of these catered to the seamen who congregated there and were thus unlikely destinations for the men who came there to plan the new federal capital.

Suter died just a few years after these momentous events took place in his establishment, and his family moved on. Not only was the original tavern torn

down, but its address was so thoroughly forgotten that all attempts to locate it on a map have thus far failed. It is therefore unsurprising that multiple attempts have been made to attach the label of Suter's Tavern to the Old Stone House. As early as 1870, a marker out front indicated that this was where Washington et al had worked. A story circulated that a number of children playing in the attic of the Old Stone House had come across "some drawings and plans which seemed to have some relation to the early plans of the city." However, even the *Washington Times*, which reported this, seems to have been skeptical of the story, adding that "no authentic history which points to any occupancy of this house by President Washington on any occasion" existed.

The most determined effort to connect the Old Stone House with Washington was begun in 1940 by one Bessie Wilmarth Gahn. Her 1940 opus, *George Washington's Headquarters in Georgetown and Colonial Days: Rock Creek to the Falls*, while correctly identifying Suter's Tavern as the location of Washington and L'Enfant's work, also went on to incorrectly make the connection between the house on M Street and the tavern.

However, this confusion did have one positive effect. In 1953, the federal government bought the Old Stone House to turn into a museum. It is the oldest surviving building in Washington, D.C., and it survived to a large extent because of the longtime uncertainty as to its use in the early days of the federal capital. Around it, hundreds of old houses fell to the wrecking ball, but the Old Stone House is a survivor—thanks to an urban legend.

"A Fine House in the Woods"

In [The Maples's] *infancy, George Washington described the then frame dwelling as a "fine house in the woods between Capitol Hill and the Navy Yard." In its maturity, today, it ranks as one of the most beautiful community houses in the country.*
—*Dorothea Jones,* Washington Is Wonderful, *1956*

The Old Stone House is not the only D.C. landmark to be incorrectly connected to the father of his country. Across town, past the Capitol, another old home has received this touristic laying on of the hands. The house is known variously as Friendship House, The Maples or the Duncanson House. It was as the last that it was originally known. Built for William Mayne Duncanson by architect William Lovering, it was one of the first nice houses

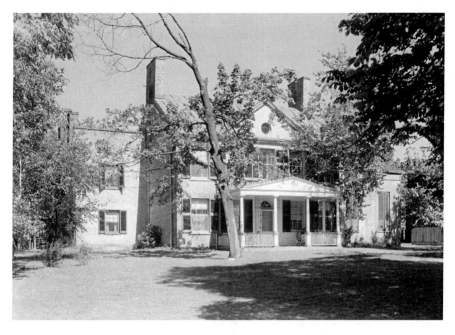

The Maples in 1935. *Historic American Buildings Survey Collection, Library of Congress.*

on Capitol Hill. It thus served as one of the centers of social life in the early years of the federal city. Duncanson was known for his parties—and his profligacy. Unfortunately, the latter trait—along with the slow development of Washington real estate in which he had sunk all his money—soon led to his financial ruin.

The house eventually fell into the hands of Francis Scott Key, from whom it eventually passed to Major Augustus A. Nicholson, quartermaster of the U.S. Marines, who lived there from 1838 onward. Once again, the house became a social center for Capitol Hill life, a situation not much dampened by Nicholson's wife's tragic suicide in 1845.

A senator from Delaware, John Middleton Clayton, was the next famous owner. He had a ballroom added, hiring Constantino Brumidi, who would become famous for his frescoes in the Capitol, to decorate the walls. Sadly, Clayton did not have much time to enjoy his new purchase, dying in the same year as he bought it. A French oceanographer, Count Louis Francois de Pourtales, was the next owner. His addition to the house was a wine cellar deep underground—the entrance to which has disappeared in the intervening years.

The longest-lasting owner of the house and one most closely associated with the house is the journalist Emily Edson Briggs, one of the first women to have access to the press gallery in the Capitol and the first to be accredited to the White House. Her writings, published under the pen name "Olivia," were read avidly across the whole country. When Briggs died in 1910, the house stayed in her family until 1936, when her daughter sold it to the Friendship House Association.

It was at the grand opening of the house in its new role that the *Washington Post* first credited George Washington with saying that it was "a fine house in the woods between Capitol Hill and the Navy Yard." Three years later, this reference was cast in metal in the form of a plaque presented by the "Historical Research Committee, District of Columbia Daughters of the American Revolution." This plaque was mounted on a wall in the courtyard that marks the entrance to the house. Since then, the connection to George Washington has been treated as gospel, and even the Capitol Hill foot-tour marker on the opposite side of South Carolina Avenue from the house proclaims Washington's supposed words.

However, looking at the historical record, it becomes clear that there is no way that Washington could ever have seen the house, let alone spoken of it. There are only a little over three years during which Washington could have seen this house and commented on it: between the Duncansons moving in to the Maples in the summer of 1796 and Washington's death in December 1799. The ex-president did indeed visit the Federal City (as he always referred to it) numerous times in that timeframe but makes no indication of having met Mr. Duncanson, owner of The Maples, nor stopping at his home. Washington usually passed through his eponymous city on the way to and from Philadelphia. He would normally stop in Bladensburg before proceeding straight on to Georgetown. Later, after he had hired William Thornton, architect of the Capitol, to build him a pair of houses just north of the Capitol, Washington would occasionally venture into the city to see how the work was progressing. In all these cases, he mentions only a small set of places wherein he dined or lodged. Chiefly among them was the establishment of Thomas Law, who owned the land at the confluence of the Anacostia and Potomac Rivers and had been a friend (or at least a business acquaintance) of Duncanson until the two had a major disagreement in 1796. Thomas Peters and the Union Tavern in Georgetown are also mentioned by Washington. Finally, his architect, Mr. Thornton, occasionally served as Washington's host.

Now, absence of evidence does not imply evidence of absence, but there really does not seem to be any time in which Washington might have made

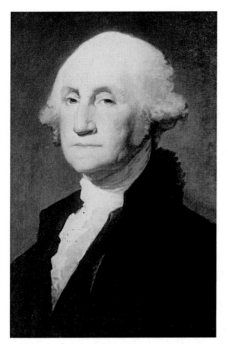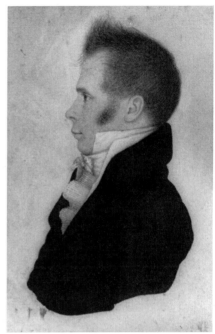

George Washington (left) and George Watterston. Details of a painting by Gilbert Stuart (Washington) and an 1811 portrait (Watterston). *Library of Congress.*

his visit. Nonetheless, this story must have come from somewhere, and the question arises, "If Washington never visited The Maples, who did call it a 'fine house'?" (an expression that Washington himself never put to paper about any dwelling).

Allen Culling Clark's 1901 book *Greenleaf and Law in the Federal City* gives a clue. In it, Mr. Clark quotes a Mr. Watterston, who describes "Cap'n Duncanson" as having "built a fine brick house in the woods between the Capitol Hill and Navy Yard." Watterston's full name was George Watterston, and he was the third librarian of Congress. After having been heaved out of office for being loudly of the wrong political party when Andrew Jackson took over the presidency, Watterston spent his time writing books and attempting to get his old job back. One of these books was a history of Washington (which could hardly have been terribly long, as the author died in 1854, when the Federal City was not yet of retirement age), and it was here that Watterston wrote of Duncanson's house. The book was never published, but somehow the manuscript made its way into Clark's hand for him to use it in his book.

Nine years after his book was published, Clark gave a speech before the Columbia Historical Society on Duncanson himself. He once again quoted Watterston, though this time he changed the quote to "a fine house in the woods between the Capitol Hill and Navy Yard." It is this wording that Dorothea Jones used forty-six years later and which is quoted at the top of this piece. Somewhere in there, a lie had been set into the world, a lie that keeps getting repeated to this day.

J Street

One thing to remember [when navigating the streets of D.C.] *though—there's no J Street (skipping the letter J was meant as a slap in the face to unpopular chief justice John Jay).*
—Frommer's Washington D.C. from $50 a Day, *1996*

The planning that went into the design of Washington, D.C., makes it relatively easy for visitors to find their way around. Streets that run north to south are numbered, while streets running east to west have letters as names. As long as you keep in mind that each address exists four times in the city—northwest, southwest, southeast and northeast of the Capitol—knowing the name of the street and the number you are looking for makes it easy to find your way.

There is just one oddity among this regularity: there is no J Street between I and K Streets, either north or south of the Capitol. This apparent oversight has led to numerous suggestions as to why such an obvious letter should have been avoided. The man most likely to have done so was Peter L'Enfant, so when people began looking for a reason why L'Enfant would have failed to name a street after the tenth letter of the alphabet, it was posited that he had a grudge with someone whose name began with "J." The obvious choice was John Jay, who not only had two of the letters in his name but whose last name also was the letter, written out.

John Jay is best known for being the first chief justice of the Supreme Court, but he had an impressive résumé stretching back all the way to 1774, when he was a delegate to the First Continental Congress. Over the years, he served as the president of the Continental Congress, minister to Spain and secretary of foreign affairs—what would today be called secretary of state.

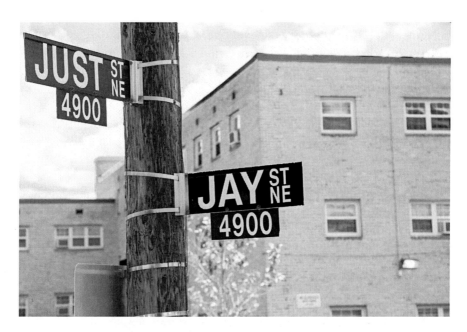

Street sign at the corner of Just and Jay Streets, in the northeast quadrant of Washington, D.C. *Photo by Maria Helena Carey.*

As far as what he did to raise L'Enfant's ire, the two possible reasons given are that Jay had an affair with L'Enfant's wife or that L'Enfant had issues with the treaty that Jay negotiated for the United States that settled some disputes left unsolved by the Treaty of Paris. Neither of these stands up to scrutiny. For one, L'Enfant never married. For the second, the Jay treaty was negotiated and signed several years after L'Enfant had been fired from his position as chief architect of Washington.

Finally, it is uncertain who actually gave the streets their names. Although the commissioners responsible for building the new capital, after meeting with Secretary of State Jefferson and Representative James Madison, sent L'Enfant a letter telling him that the streets were to be lettered and numbered, no map from L'Enfant shows this scheme. The first map that applies specific letters to specific streets is one engraved by Samuel Hill on July 20, 1792, about five months after L'Enfant was fired. It is thus unclear whether L'Enfant or his replacement, Andrew Ellicott, made the decision.

So why was there no J Street? Some have posited that "I" and "J," as they were written back then, looked too similar. However, looking at both handwritten samples as well as printed letters of the time reveals the

differences to be as strong as, if not stronger than, today. No, the real reason was because in the late eighteenth century, the letters were considered interchangeable. In fact, looking at a dictionary printed around that time, such as William Pardon's *A New General English Dictionary*, published in London in 1781, it is clear that these were one and the same letter. While the section following those words beginning with the letter "H" is headed simply "I," the first thirty-seven words all begin with the letter J; the first word beginning with "I" is the little-used and almost unpronounceable "Iatraliptick."

Another person who combined "I" with "J" was none other than Peter L'Enfant. On his original map of D.C., he lists a number of points of interest on the map. The first, marked with an "A," is the location of the Washington Monument. There is a point "I," what is today The Ellipse, south of the White House, and one marked "K," which is apparently Lafayette Square, north of the White House. But there is no "J." Thus, whoever named the streets of Washington that run east to west made no attempt to disparage anybody—only an attempt to ensure that people would not be confused by two streets with names that could be considered interchangeable.

Finally, while there is no J Street in Washington, there is a Jay Street. It is located in the northeast quadrant of D.C., almost in the easternmost corner. Its namesake? None other than the Supreme Court justice John Jay. Some pranksters have even been known to paint out the "a" and "y" on the signs, creating a real J Street for D.C.

THE EAST CAPITOL STREET SLAVE MARKET

East Capitol Street between First and Second Streets was an open market in the middle of the street which could be seen by Lincoln from the windows of his boardinghouse and from the Capitol. He called these "a sort of Negro Livery Stable."
—*Ralph S. Gary,* Following in Lincoln's Footsteps, *2002*

Although born in Kentucky, a state that continued to accept slavery until the ratification of the Thirteenth Amendment, Abraham Lincoln moved with his family to Indiana in 1816, and thereafter, he lived only in free states. It was not until his move to Washington, D.C., where he took up his seat in the House of Representatives in 1847, that he once again lived in a slave-owning state. Lincoln had observed slavery during trips to New Orleans and visits

to Kentucky, but during the two years that he lived on Capitol Hill, he was frequently confronted with the realities of this blight on the United States.

The Lincoln family lived directly east of the Capitol, in the middle of a row of houses that extended from A Street SE to B Street (today Independence Avenue). While he lived there, one incident would come to define the evils of slavery for the young representative.

Lincoln's landlady, Mrs. Sprigg, had hired a young slave who was in the process of buying himself free. A fellow boarder, Joshua Giddings, described what happened three days later in a speech given on the floor of the House:

> [O]n *Friday last, three armed persons, engaged in the internal slave trade, entered a dwelling in this city and violently seized a colored man, employed as a waiter in the boarding-house of several members of this body, and, in the presence of his wife, gagged him, placed him in irons, and with loaded pistols, forced him into one of the slave prisons of this city, from which, it is reported, he has since been dispatched for the slave market at New Orleans;*
>
> [S]*aid colored man had been employed in said boarding-house for several years, had become well and favorably known to members of this House, had married wife in this city and, under a contract to purchase his freedom for the sum of $300, had, by great industry, paid that sum within $60.*

In 1854, Lincoln would describe what he could observe from his place of work:

> *The North clamored for the abolition of a peculiar species of slave trade in the District of Columbia, in connection with which, in view from the windows of the capitol, a sort of negro-livery stable, where droves of negroes were collected, temporarily kept, and finally taken to Southern markets, precisely like droves of horses had been openly maintained for fifty years.*

There indeed were slave pens visible from the Capitol—they were located on Maryland Avenue near the intersection of Seventh Street, in the southwest quadrant of the District. Two particularly notorious pens located there were run by William H. Williams and a Mr. Robey. The cruelty displayed by their owners was well documented, both by travelers appalled by the notion of slavery and those who had been held there. They were used until 1850, when the slave trade—though not the institution itself—was banned in the District of Columbia. It was these pens that Lincoln was no doubt referring to.

But what about the market on East Capitol Street?

The view from the Capitol during the Civil War. The slave market in Lincoln's time as a representative is visible just to the right of the white building to the center-left of the picture. *Library of Congress.*

View of the Capitol from the corner of East Capitol and First Streets. The market was in the middle of this stretch of road. *Photo by Maria Helena Carey.*

In 1812, the city of Washington had realized that those who lived near the Capitol were underserved by the current food markets. The decision was thus made to build a new market, closer to the Capitol. Accordingly, on December 21 of that year, the city council passed "an Act to establish a market on the Capitol Hill." In it, $300 was appropriated to not only erect a building but also to acquire the proper weights and build a scale house. The market was to be built "in or near East Capitol Street."

The last proviso proved to be the most troublesome, as the city did not own any tracts of land there that could be used for this purpose. It was thus decided to build in the middle of the street. Given the width of the street and the paucity of traffic, this seemed to be an excellent decision. On February 1, 1813, the new market opened, serving the public on Mondays, Wednesdays and Fridays.

Over the next years, further appropriations were made to enclose and pave the new market, and refinements were made to its operation, whether to allow it a Saturday market, to pay the clerks or to allow tin peddlers to hawk their wares alongside the butchers and vegetable merchants. One attempt to undermine the market came in 1816, when the city passed an ordinance (fortunately never carried out) that would have used these buildings "for the temporary accommodation of the circuit and supreme courts."

Instead, the market continued operating until 1838. On October 25 of that year, the city council passed a law providing "for the sale and removal of the Capitol Hill market house." A buyer for the buildings was to be sought, with the stipulation that the new owner would have about a month to remove the houses. The city would thereafter regrade and re-gravel the street, leaving it as it once was. No reason is given for this action, though perhaps it was felt that a market was not the appropriate neighbor to the newly completed Capitol and grounds. No trace whatsoever remains of this chapter of Hill history.

Thus, Lincoln could not have seen this market, as he did not arrive in D.C. until ten years later. Nonetheless, these two markets have merged in popular memory to create this urban legend. Certainly, the image of the young representative looking up from his comfortable chair in the parlor of his boardinghouse to be confronted with the true face of slavery—the actual buying and selling of human beings—is even more viscerally appalling than the horrifying sight of shackled beings a half mile down below the Capitol.

Monuments and Memorials

The main focus of a visit to Washington is the National Mall, sweeping west of the Capitol, and its many memorials. The memorials have collected their own set of stories, with the Washington and Lincoln Memorials being the most prominent.

HIGH-WATER MARKS

My father always told everyone that the color change [one-third of the way up the Washington Monument] *was the high-water mark from the Johnstown flood. Everyone always believed it. It was always great fun to hear those he had told tell others.*
—*commenter at Penn Quarter Living, March 23, 2008*

One of the first things visitors to Washington, D.C., notice upon arrival is that the Washington Monument, rather than being a pure white column, actually changes color one-third of the way up the shaft. The reasons supposed for this are varied, and some—like the comment shown above, which references a flood that occurred 180 miles from D.C.—are fairly obvious jokes, but the real reason, as is so often the case, is more interesting than any made-up story.

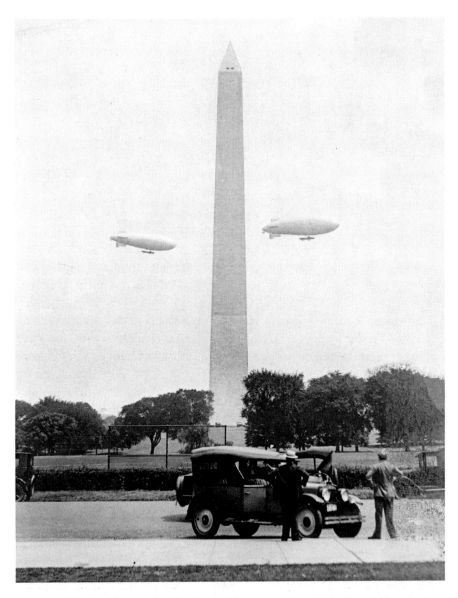

Two army blimps in front of the Washington Monument, circa 1925. *National Photo Company Collection, Library of Congress.*

Although Peter L'Enfant had left space on his plan for the new federal city for an "equestrian statue of George Washington" due south of the President's House and due west of the Capitol, it was not until after Washington's 100th

birthday in 1832 that a concerted effort was made to build it. The following year, the Washington National Monument Society was founded, and within four years, it had collected enough money to begin planning. A competition led to the selection of Robert Mills as the architect. His design was quite different from the monument as built. While a tall central obelisk remained the central element, Mills also foresaw a colonnade surrounding the shaft, surmounted by a statue of George Washington driving a *quadriga*, a Roman four-horse chariot.

With money tight, the society decided to begin building just the central column, figuring that money would flow when work began. Thus, on July 4, 1848, a large crowd turned out to watch the ceremonial laying of the cornerstone. Work proceeded from there, and over the next six years, the shaft rose about 150 feet into the air, almost one-third of the proposed height. During this time, numerous organizations around the world sent plaques to be added to the monument. Chiefly among these were stones from each of the states, but other societies and groups sent them as well. One person who wanted to show his respect for the first president of the United States was none other than Pope Pius IX, who sent a block of marble for inclusion. It arrived in D.C. in October 1853. Members of the Know Nothing Party, a radical anti-immigrant and anti-Catholic political party that had been growing in power and was on the cusp of actual electoral success, were incensed by this action. In early March 1854, several of them broke into the grounds of the nascent monument, tied a rope around the hut of the guard so that he could not intervene, removed the stone from the lapidarium in which it was stored, broke it and threw it into the nearby Potomac. The action had two effects, both problematic for the memorial. First, money—which had been tight all along and was already on the verge of drying up—disappeared. Second, the Know Nothings took over the control of the Monument Society. Calling an extraordinary meeting, which they packed with their supporters, they managed to gain enough control that it would be years before the situation was sorted out.

In this time, the new leaders managed to build a few courses of stone, using marble that had been cast aside as insufficiently perfect. With no new stone being quarried and no money to buy it, this effort soon petered out. On top of that, the 1857 economic collapse—which the country did not recover from before the Civil War—ensured that no further work was done. So the monument sat, a stump, while war raged up and down the countryside. The surrounding land was used to pen cattle brought into the city to feed its citizens. The interior, open to the sky, was battered by the elements.

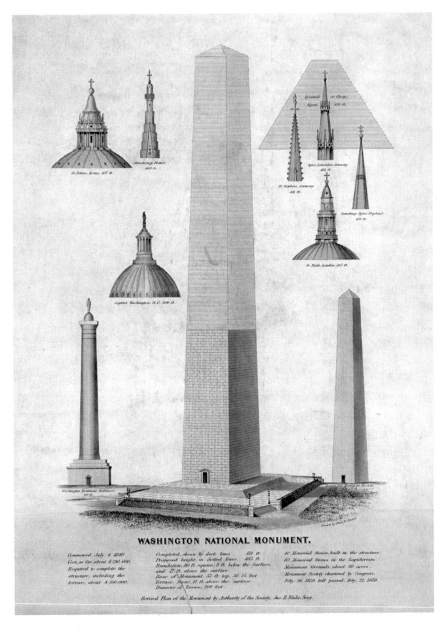

WASHINGTON NATIONAL MONUMENT.

Plan for the completion of the Washington Monument, as drawn by Fred D. Stuart. The completed portion is in darker ink. Also shown are the Bunker Hill Monument in Boston and the Washington Monument in Baltimore, as well as the tops of seven European churches and the Great Pyramid of Cheops. Under this plan, which was shelved, the monument would have risen to only 485 feet. *Library of Congress.*

Even after Lee's surrender, no immediate effort was made to complete the monument. It was not until eleven years later that a new start was made. In 1876, Congress passed an appropriation for its completion, and the task fell to Thomas Lincoln Casey, a lieutenant colonel in the Army Corps of Engineers. Casey turned out to be exactly the right man for the job, and he immediately set about cleaning up the work site, as well as analyzing the part of the structure that had been built. After repairing the foundation, the next question was getting enough marble to build the remaining four hundred or so feet. For this, Casey turned to a quarry in Sheffield, Massachusetts, whose output was quite similar to the original marble from Texas, Maryland.

Unfortunately, the Sheffield quarry was unable to provide the marble as required by its contract, so after building about six feet, Casey canceled the contract and went back to a more local quarry, this one in Beaver Dam, Maryland, not far from the original Texas quarry, and thus from the same basic stone as the pre-1854 marble, though far enough away that there was a distinct color difference between the two stones.

The Beaver Dam quarry had its issues as well and even lost its contract for a while, but other sources were even more hopeless, and thus all further marble was supplied by this quarry, right up to the final fifty-five-foot pyramidion that Casey added to the top. On December 6, Casey placed both the top capstone and an aluminum apex on the top—and the Washington Monument was complete.

The change in color (two changes, actually) that can be seen are thus a result of political squabbles and money troubles, not any flood.

Women and Children Last

Finally, the [Washington] *monument was opened to the public on October 9, 1888. The steam elevator that carried passengers to the top was considered so dangerous that only men were permitted to use it. The hazardous ride was eased, though, because the lift's male passengers were served cheese, wine and beer during the time-consuming trip up and down. Meanwhile, women and children had to make the exhausting climb up the 897 steps to the top and back down again on foot.*
—Bryson B. Rash, Footnote Washington, *1983*

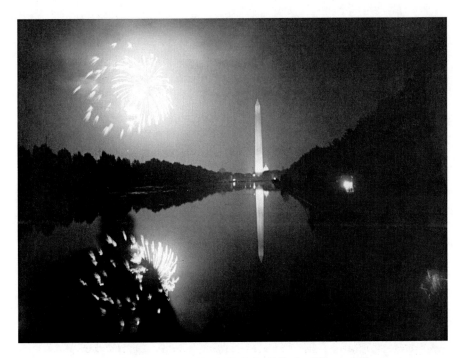

Fireworks over the Mall, July 4, 1939. *Harris & Ewing Collection, Library of Congress.*

That an elevator was a relatively new invention in the 1880s is unchallenged. The first passenger elevator had been installed in 1857 and only covered five floors. Suddenly, here was an elevator that went up five hundred feet—and took ten or so minutes to make the trip. That some of the passengers would show some trepidation before and during this journey is thus entirely unsurprising.

However, pretty much everything else in this story does not match reality. First, people had been using an elevator to go up the Washington Monument long before 1888. In fact, they had been using the elevator installed in the building in 1880 to lift the heavy stones of which the monument was built. As an elevator built for this, it had few, if any, safety precautions, consisting simply of a 9.5- by 9.5-foot platform that was raised by cables. If you wanted to take a trip to the top, you would enter the monument through the door marked "Positively No Visitors Allowed on Monument" and then hop aboard when it began its trip up the shaft. According to an unnamed writer who wrote of a trip in the elevator for the St. Paul, Minnesota *Daily Globe*, "I had to sit down and hug the stone to avoid dizziness."

In 1885, shortly after the monument's completion, the *Washington Evening Star* interviewed Edward R. Wayson, who had been the elevator operator since it had first been used in July 1880. By trade a carpenter, he had been put in charge due to his "carefulness and strict attention to orders."

Wayson turned out to be quite chatty, and the stories he told paint a picture quite contrary to the description of him. On certain days, he had been overrun by visitors to the point where he was forced off the platform, and only by explaining that the elevator was not going anywhere without his presence was he allowed back on board. Entreaties to those who were at the edge of the platform similarly failed to elicit acquiescence, so Wayson would raise the platform until those at the edge were forced to step down—or ride all the way to the top just inches away from a long plunge down. Wayson also noted that the "majority of [his] passengers have been ladies, and what impressed [him] most was that they showed much less timidity than men. Of course, as soon as a passenger showed fear, the elevator was at once

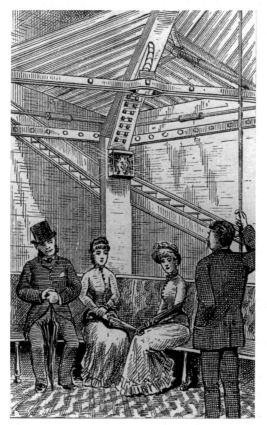

lowered to the bottom. Those were orders. But, as I said, we have had to return oftener for men than for ladies."

Although there were some attempts to keep order, it was possible to step off the elevator onto the landings that lined the inside of the monument. In one case, a rider stepped off in mid-ride. Wayson's response was to keep going, leaving the man to struggle up the rest of the way. His reasoning was that were he to let him back on, it would encourage others to try the same dangerous stunt.

Riders in the elevator. Taken from Stilson Hutchins and Joseph Moore's 1887 book *A Souvenir of the Federal Capital. Library of Congress*.

Shortly after this article ran, it was decided that the elevator was too dangerous and should be enclosed for proper use. For the next year and a half, as work proceeded, visitors had to walk up and down the Washington Monument armed only with a guttering candle, prone to blowing out at inopportune moments and leaving the climber in the dark. By late November 1886, the new elevator was ready and tested, at which point another problem cropped up: no money had been appropriated by Congress to pay to run the elevator. This sorry state of affairs continued until October 2, 1888, when the Sundry Civil Appropriations Bill, which included money to operate the elevator, was passed by Congress. President Cleveland, just a month out from losing the presidency, signed the bill into law, and—proceeding with impressive speed—the elevator was ready on October 9. At 1:46 p.m. on that day, a small crowd of twenty-three men and thirteen women assembled for the opportunity to go up in the first official trip. Only thirty-two of them were allowed on board, but there is no doubt that some of the women were among the first passengers on that first ten-minute ride up. Women have thus never been prohibited from riding the Washington Monument elevator.

And what about the "cheese, wine and beer" being served on board? This, too, seems to be entirely a figment of someone's imagination.

LOOKING BACK ON LINCOLN

The hair on the back of Lincoln's head [on the statue in the Lincoln Memorial] *appears to form the profile of Robert E. Lee, commanding general of the Rebel army of the Confederacy.*
—Travel & Leisure Guide to Washington D.C., *1997*

The Lincoln Memorial is one of the most-visited sights in Washington, D.C. Presiding over the far western end of the National Mall, the giant classical columns of the Henry Bacon–designed building bookend the wide swath of grass and memorials that stretch to the Capitol. Inside, the statue by Daniel Chester French looks out over the crowds in silent, marble contemplation. Lincoln's head is carefully sculpted to match the many pictures of him that exist, as is his hair.

There is no doubt that Lincoln's hair is, well, tousled. Maybe even messy. Thus, it is possible to see any number of different shapes in it, shapes that

Side view of the head of the Lincoln statue in the Lincoln Memorial. This photograph was taken during the 1955 renovations of the memorial. *Historic American Buildings Survey Collection, Library of Congress.*

might even be a face. However, which face is uncertain. Some say it is Lee's, others claim John Wilkes Booth and still others Jefferson Davis. Lee is the general favorite, however, as the back of Lincoln's head is pointing directly at Lee's old home at the top of the hill on the other side of the Potomac in what is today Arlington Cemetery.

So did a sculptor with Southern sympathies insert the face of Lincoln's greatest foe to remain on the back of his head, staring toward his old homestead? Or is it just the usual human need to find irony and patterns in any medium?

There is nothing in the history of Daniel Chester French that would indicate any sort of Southern sympathy whatsoever. He was born in New Hampshire and other than a brief stint in Washington lived and worked in New England his whole life. He moved with his family to Massachusetts,

where he later attended the Massachusetts Institute of Technology before striking out as a sculptor. Even among his family there is no indication of any Southern sympathy. His father, Henry Flagg French, was a lawyer and judge in New Hampshire and Massachusetts, eventually moving to Washington, where he was second assistant secretary of the United States Treasurer. Henry French's half brother was Benjamin Brown French, who was reappointed commissioner of public buildings by Lincoln and thus in charge of Lincoln's first inauguration and the funeral of Willie Lincoln (and that of Lincoln himself), as well as composing a hymn sung immediately before Lincoln gave his Gettysburg Address.

Furthermore, the statue itself was carved by the Piccirilli Brothers firm, six master carvers who worked on a huge number of carvings for various sculptors. They had previously worked for Daniel Chester French in 1913 and were brought on board to convert French's plaster version of the Lincoln statue into a full-size marble reality. Like French, the Piccirilli brothers were entirely free of Confederate sympathy, having been brought up in Italy and not moving to the United States until 1887.

Finally, there is also the question of the time when the statue was executed. Although the stark differences between North and South had been mitigated in the fifty years since the end of the war, there were still animosities aplenty. The attempt by Virginia to add a statue of Robert E. Lee to the national statuary collection in 1903 had ended in failure after an enormous outcry by the Union veterans' organization. It would not be until twenty years after French received his commission that Virginia would get its way in this regard.

In short, a sculptor with Confederate sympathies might well have tried to do something such as adding a surreptitious face to the back of a monument, but there is no indication whatsoever that either French or the Piccirilli brothers were in any way inclined in this direction. There is thus no doubt that any face visible in Lincoln's hair is simply the product of suggestion and an overactive imagination and the usual human love for finding patterns and, of course, a good story.

Just a few miles across town, there is another example of this. In 1936, Barry Faulkner painted two murals for the interior of the Rotunda at the National Archives. One depicts the signers of the Declaration of Independence, standing outside under a cloudy sky. In the dark cloud that appears above Thomas Jefferson's head is a face, one that some insist is that of Lincoln. Given Garry Wills's assertion that Lincoln's Gettysburg Address was no more and no less than a restatement of Jefferson's immortal words, it would

not be out of place to include Lincoln in this picture. Closer examination reveals the "face" to indeed have the chin beard and sloping forehead of Lincoln but also a hooked nose quite different from the president's. And his mouth is open, prompting one observer to declare that what it portrayed was really the "Old Man of the Mountain sneezing."

SPELLING THE PRESIDENT

The [Lincoln Memorial] *was designed by Henry Bacon, the statue by Daniel Chester French. Both were completed in 1922. French had a son who was deaf, and the sculptor was familiar with sign language, so Lincoln's left hand, resting on the arm of the chair, is shaped in the sign for "A," while his right hand makes an "L."*
—*Evelyn and Dickson,* On This Spot, *1992*

For such a simple memorial, the monument to Abraham Lincoln has a remarkable number of symbols packed into it. It consists, after all, of a columned room with a seated statue of Lincoln inside. Looking more closely, however, reveals subtle and telling details that Henry Bacon and Daniel Chester French added to give life and meaning to the memorial. From the large (the number of columns surrounding the monument is equal to the number of states that were in the United States after the Civil War) to the small (the position of Lincoln's feet is a tribute to Lincoln's resolve and his hope for reconciliation), the memorial's features strive to explicate the sixteenth president's time in office.

One feature that has intrigued visitors is the shape of Lincoln's hands. Resting loosely on the arms of his massive chair, the fingers are curled in a way that has given people pause from the beginning. An early viewer wrote, two years before the memorial's dedication, that he saw "the right hand partly open as if to receive all the facts of life, [and] the left hand firmly clenched as though to hold and use them to best advantage."

Shortly after the dedication, another story began to circulate: that the fingers were posed in the form of the American Sign Language "A" and "L," the president's initials. Over the years, further details were added. It was said that the signs were added to celebrate Lincoln's signing of the Columbia Institution for the Deaf and Dumb and Blind's authorization to grant college degrees, an important step in converting the institution from a small school

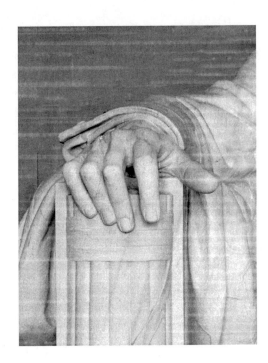

Right hand of the Lincoln Statue in the Lincoln Memorial. *Historic American Buildings Survey Collection, Library of Congress.*

into the internationally known Gallaudet University, or that it was a nod to French's son (or daughter), who was deaf.

There is no indication that any of this is true. French did not have any deaf children; his only child, Margaret French, was decidedly not deaf. He insisted that the shape of the hands was simply given by the life casts of Lincoln's hands that he used to sculpt the memorial and that he had relaxed them slightly, giving them the shape they have. Furthermore, he wished the pose of the hands to support the meaning of the statue. As he wrote in a 1922 letter: "What I wanted to convey was the mental and physical strength of the great war President and his confidence in his ability to carry the thing through to a successful finish. If any of this 'gets over,' I think it is probably as much due to the whole pose of the figure and *particularly to the action of the hands* as to the expression of the face." [author's italics]

Complicating the discussion is that French had, many years previously, actually sculpted a statue whose figures are signing. This statue depicts Thomas Hopkins Gallaudet and his student, Alice Cogswell, signing the letter "A." French had made this statue in 1889, and today it stands near the main entrance of the university named for Gallaudet.

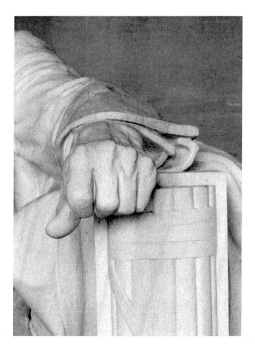

Left hand of Lincoln Statue in the Lincoln Memorial. *Historic American Buildings Survey Collection, Library of Congress.*

So what was it? A deliberate decision the sculptor later repudiated? Simply happenstance? Or a subliminal reminder by the artist of a previous statue? There is probably no way to find, definitively, the answer to the question. It should thus be left, simply, as one of those levels of meaning that have been added to the memorial since its unveiling.

Loose Cannons

In World War II, the army mounted antiaircraft guns atop the Department of the Interior's main building. Several rounds were accidentally fired, causing the destruction of the state seals of Maryland, Connecticut and Texas on the face of the Lincoln Memorial.
—*Bryson B. Rash,* Footnote Washington, *1983*

On the morning of December 7, 1941, Japanese aircraft attacked Pearl Harbor, drawing the United States irrevocably into World War II. The attack jolted many Americans from their complacency. After all, United

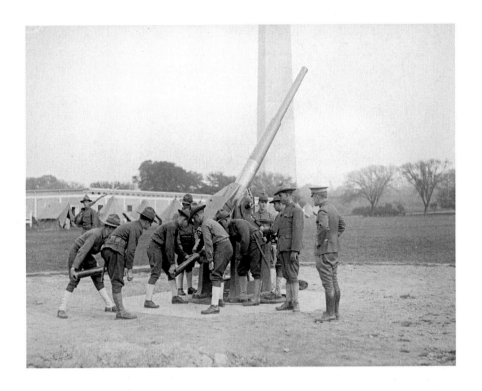

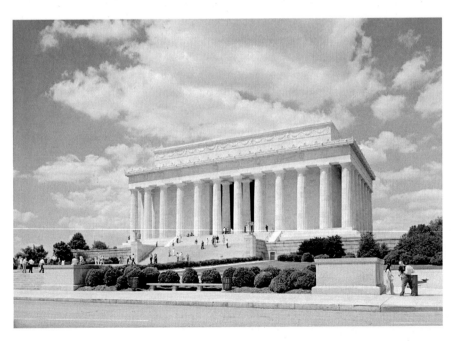

States territory had not been attacked in almost 130 years, but with airplane technology evolving rapidly, it appeared that no place was safe anymore.

Central Washington, D.C., had not been under direct attack since the War of 1812. The closest it came was in 1864, when Fort Stevens, just north of the city proper but still inside the District, was attacked by Confederate forces under General Jubal Early. Nonetheless, after Pearl Harbor, there was an immediate rush to fortify the city against the Japanese or German bombers that were sure to swoop over the city at any time.

In order to protect Washington, a three-tiered defense system was thrown up around it. The front line was a ring of observation posts outside the city limits, allowing any approaching German or Japanese bombers to be spotted well before they could do any damage. Inside this ring, searchlights would pick out the aircraft as they approached, allowing the third ring, a series of guns that would throw up "a 'virtually impenetrable' curtain of anti-aircraft fire," to shoot down the invaders. These guns were placed throughout D.C., including on top of government buildings in the very center of the city. They consisted of both antiaircraft weapons such as Bofors, which could launch two 40-mm shells per second, and machine guns, which could shoot five times as many half-inch bullets into the air in the same time.

At 10:00 a.m. on September 3, 1942, a soldier accidentally pulled the trigger on one of the machine guns stationed in central D.C. Before he could react, four bullets had been unleashed from the gun's muzzle. Three of them struck the cornice of the Lincoln Memorial, hitting the frieze containing the names of the forty-eight states that existed when the memorial was unveiled. (The fourth flew over the memorial and ended up in the Potomac.)

The next day, the *Washington Post* ran a page-one article entitled "Lincoln Shrine Hit by Accidental Machinegun Fire." The article itself, a model of concision, recounted the facts and said that both the army and the Public Buildings Administration were launching inquiries into the event. The *New York Times* also published an article, which was even shorter than the *Post*'s.

Opposite, top: Antiaircraft guns being deployed below the Washington Monument during World War II. *Harris & Ewing Collection, Library of Congress.*

Opposite, bottom: East front of Lincoln Memorial, as seen from the northeast. *Historic American Buildings Survey Collection, Library of Congress.*

No further mention of the incident is made in either paper, nor were the results of either investigation ever publicized. It thus fell to word-of-mouth to keep the memory of this event alive, and so there are enough variants of the story that it has—in spite of its apparent truth—taken on the appearance of an urban legend. The most notable variant is that it was an antiaircraft shell, such as one fired by the previously mentioned Bofors, that hit the memorial, not a series of machine-gun bullets. It is, however, fortunate that it was the latter and not the former, as the damage done by the shells would have been far more severe. The story is also invariably told that the blast came from the roof of one of the government buildings. While this is logical, as the best-known defensive guns in D.C. were on these rooftops, nowhere in the original telling of the tale is the source of the gunfire revealed. Another version has "the lanyard absentmindedly pulled," precipitating the firing— something that would rule out a machine gun as the source.

These various tellings all mention details that were either omitted in original newspaper reports or were added simply to make for a more compelling tale. Nonetheless, in contrast to most of the other stories in this book, the key takeaway, namely that the Lincoln Memorial was the only building in Washington, D.C., to be stuck by ordnance during World War II, is actually true.

THE HOOF CODE

When all four of the horse's hooves are on the ground, it means that the rider died a natural death. One hoof in the air means that he died from wounds he received in action. If two hooves are raised, it means that the rider was killed while fighting a battle. [Answering a question about the meaning of the hooves in an equestrian statue]
—*Don Blattner,* Amazing Facts About Mammals, *2006*

Equestrian statues have been part of Western culture for over two and a half millennia. As a means of showing a leader at his most heroic, few images are more impressive. Since 1852, when Clark Mills cast the first equestrian statue in the United States (a bronze of Andrew Jackson on a rearing charger), leaders, particularly military leaders, have been shown riding high in their statues.

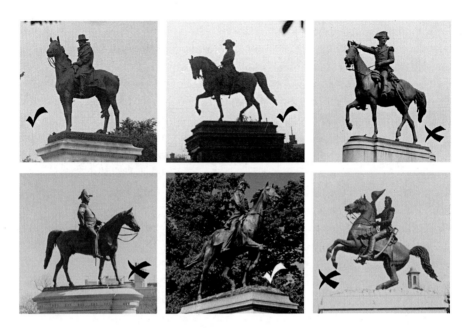

Six of the equestrian statues in Washington. *Top row, from left*: Ulysses S. Grant at east end of National Mall. Follows hoof code: all four hooves are on the ground, and Grant passed away in peace. *National Photo Company Collection, Library of Congress*; John A. Logan. Follows hoof code: three hooves are down, and Logan was wounded at the Battle of Fort Donelson but died in peace. *National Photo Company Collection, Library of Congress*; Revolutionary War hero Nathanael Greene, Stanton Park. Does not follow hoof code: Greene survived the war unwounded, but three hooves are on the ground. *National Photo Company Collection, Library of Congress. Bottom row, from left*: Winfield Scott in Scott Circle, Washington, D.C. Does not follow hoof code: although Scott was wounded during the Battle of Fort George during the War of 1812, all four hooves are on the ground. *Historic American Buildings Survey Collection, Library of Congress*. Philip Kearny in Arlington Cemetery. Follows hoof code: Two hooves are down, and Kearny was killed in 1862 during the Battle of Chantilly. *Carol M. Highsmith Collection, Library of Congress*. Andrew Jackson, Lafayette Square. Does not follow hoof code: Jackson was wounded during the Revolutionary War but recovered to become the hero the Battle of New Orleans and president of the United States. Statue shows two hooves on the ground. *Library of Congress*.

Since Jackson's statue was unveiled in Lafayette Square, just across Pennsylvania Avenue from the White House, twenty-three other equestrian statues have been added in Washington and Arlington Cemetery, celebrating the life and work of twenty-two different leaders in battle, politics and religion. George Washington and Simon Bolivar are accorded the special honor of being represented twice. There is also a statue of Lincoln standing next to a horse next to his cottage in the Armed Forces Retirement Home, but since Lincoln is not sitting on the horse, it is excluded from the following analysis.

Over the years, the story has circulated that it is possible to determine the fate of the rider in an equestrian statue by looking at the hooves of the horse on which he sits. A horse with all four feet touching the ground indicates that the rider survived all battles uninjured and eventually died of natural causes. Three hooves on the ground means that the rider was injured at one point or another in battle but survived to die later of other causes, or that the rider died of injuries caused during the battle. Finally, when the horse only has two hooves on the ground, it means that the rider was killed during a battle. Some versions of the story state that this is true only in Washington, D.C., while others claim that it is universally true. However, a look at the statues in D.C. shows that there is no basis for the rumor.

The subjects of the twenty-four statues with recognizable people riding them in Washington and Arlington Cemetery range from important leaders, both military and political, from across the United States and Central and South America; to historical figures, such as Joan of Arc; to two church leaders, John Wesley and Francis Asbury. Of the twenty-four, only eight follow the code. This is almost exactly the number one would expect if the distribution were random. In other words, it is not even true that some sculptors adhere to this rule while others do not, as has been suggested by some.

The question remains, then, where the code came from. It turns out that there was a time and place where it worked: Gettysburg National Military Park, from 1896 until 1998. The first two equestrian statues to be added at Gettysburg depicted Union generals Winfield Scott Hancock and George Meade. Hancock was wounded at the Battle of Gettysburg, and his horse has three hooves on the ground. Meade, uninjured in the battle, sits astride a horse with all four feet on the ground.

Two years later, a statue of Union general John F. Reynolds was added. Reynolds, who was killed on the morning of the first day of the battle, is shown on a horse with its front right and rear left hooves off the ground. The next three soldiers to be honored in Gettysburg had all escaped the battle unscathed and are shown on horses with all four hooves resting on the ground. It was sometime after 1917 that people began noticing the pattern, and letters in the park's archives begin referring to it in these years.

Thus, when the next statue, that of Confederate general Robert E. Lee, was unveiled in 1932, people were pleased to note that the unscathed general sat on a horse with four feet attached to terra firma. However, even before that there had been great efforts to stop the myth from spreading. One of the more impressive efforts came from the pen of Major Edgar E. Davis,

superintendent of the park. He had been sent a letter regarding the hoof code and sent this comprehensive reply:

Dear Sir:

Your letter of October 19, 1931, is received and noted.

The story that the posture of the horse in equestrian statues on this battlefield indicates whether the rider was killed, wounded, or unhurt seems to be one of those myths which grow up around historical places and are almost impossible to destroy. Sculptors whom I have consulted assure me there is no such convention connected with the art.

This office does not countenance the story. On the contrary, it invariably discourages it. It seems, however, to appeal to some imaginations among both guides and tourists.

If you are in position to supply the name of your guide or the number of his cap, I can possibly stop one from further reciting the myth.

Very truly yours,

E.E. Davis,
Superintendent

It would be sixty-six years before another equestrian statue would be added to the plethora of monuments on the grounds around the high-water mark of the Confederacy. During this time, the guides who helped visitors understand how the battle played out continued to use the hoof code to keep track of the outcomes for each of these individuals. They were thus put out when they found out that Gary Casteel, who had been given the commission to create this new statue, envisioned a monument quite different from the others. Rather than having the general sit on his horse atop a pedestal, far from the visitors, he wanted it to show the action on the ground level. This, of course, required a horse to be posed with at least one hoof off the ground. The guides' distress stemmed from the fact that Casteel's subject, Confederate general James Longstreet, had, in spite of his central role in the battle, managed to survive it without a scratch. Casteel was forced to confront the guides, telling them that there was no rulebook stating that he had to design his statue one way or the other. To bolster his case, Casteel even found a letter in which the sculptor of the Reynolds statue wrote that he was motivated purely by artistic motivations in raising two hooves off the ground.

Casteel prevailed, and his statue has become one of the most popular in Gettysburg. And tour guides both there and in Washington still have to explain that there is absolutely no meaning to the horse's hooves in an equestrian statue.

CHAPTER 3

Presidential Legends

G iven the mystique of power surrounding the president and the White House, it is hardly surprising that numerous legends have grown up around the office. This includes the name given to the building in which the president lives and works.

WHITEWASHING THE WHITE HOUSE

Do you know…that the executive mansion is constructed of sandstone, which was so marred by fire and smoke when burned by the British in 1814 that it was painted white (hence the name White House) and that it has been painted frequently since that act of vandalism?
—Washington Post, *February 13, 1921*

We have become so accustomed to the name "White House" when referring to the building that the president of the United States occupies that it is slightly jarring to step back and realize that these two words in fact describe a huge number of the houses in the United States. It is thus unsurprising that the genesis of the name has generated its own legend.

When Peter L'Enfant drew his famous map of the new capital, the location of the White House was labeled simply "President's House." For

the next one hundred years or so, this was used along with "Executive Mansion," "White House" and the odd constructions "President's Palace" and "Presidential Palace." While the phrase "President's House" initially was the most used, somewhere in the 1830s, it began dropping in use, with "White House" beginning to dominate. "Executive Mansion," "Presidential Palace" and "President's Palace" never caught on in the same way.

In 1901, Theodore Roosevelt made the name official by having stationery printed with "White House, Washington" at the top. In contrast, previous presidents had used the formulation "Executive Mansion, Washington" instead.

The building itself was begun with the laying of the cornerstone on October 13, 1792. Over the next eight years, construction proceeded fitfully, and when President John Adams moved to Washington in the summer of 1800, it was not yet completed. By the time he and his wife managed to move in, Adams had already lost the presidency to Thomas Jefferson, so his tenure in the new building was short indeed. Thomas Jefferson spent eight years there, while his successor, James Madison, found himself, midway through his second term, turned out of his residence by the threat of invading British troops.

On August 24, 1814, finding the President's House empty, the invaders torched it. All that was left of it were the outside walls, which were badly scorched. In fact, other than the south front, nothing could be saved. Over the next two years, the White House was rebuilt, and Madison found himself back in residence—just in time for him to turn over the keys to James Monroe.

In the process of rebuilding the President's House, whitewash was used to cover the stone of which it was built. It is due to this treatment that the building is purported to have gotten its name. Unfortunately, there are a number of problems with the story.

First, whitewash was used on the White House long before the War of 1812. The building is made of Aquia Creek sandstone, which has been used in many buildings across Washington, D.C., but is not known for its ability to withstand the weather, as it turns a mottled dark gray after exposure to the elements. As early as 1798, the still-unfinished building was whitewashed in order to protect the stone. Even after completion, the whitewashing continued, presumably to give the whole structure a uniform color.

Opposite, top: Exterior of north portico of White House, circa 1908. *Library of Congress.*

Opposite, bottom: Aquatint showing the President's House after the burning of Washington, August 24, 1814. Painted by George Munger and engraved by William Strickland. *Library of Congress.*

Second, the name "White House" was actually used prior to its burning. In a letter written on April 24, 1811, by Francis J. Jackson, recently dismissed minister in Washington (as the British ambassador was then called), to United States senator and previous secretary of state Timothy Pickering, Jackson writes of a possible replacement for himself: "[Augustus Foster] goes, therefore, as well to satisfy the claim of the United States to a minister of the same rank as their own as to act as a sort of political conductor to attract the lightning that may issue from the clouds round the Capitol and the White House at Washington."

Clearly, the nomenclature was well known by then, especially given Jackson's capitalization thereof.

In short, the name "White House" does indeed stem from the paint used to cover the outside of the President's House (without the paint, it would be known as the Gray House), but the whitewashing has nothing to do with the fact that it was burned by the British in 1814.

The Curse of Tecumseh

Every U.S. president elected in a year divisible by twenty has died in office. Is this merely a coincidence, or as many American Indians believe, the fulfillment of a curse laid upon William Henry Harrison and all subsequent U.S. presidents elected in a year ending with a zero? In the War of 1812, Harrison, promoted to major general, recaptured Detroit from the British and in October 1813 defeated them and their Indian allies, led by the Shawnee chief, Tecumseh, and his brother, the Prophet, in the Battle of the Thames in Canada. Tecumseh was killed in this battle. Legend has it that the Prophet, who was the Shawnee shaman, or medicine man, thereupon invoked a curse upon Harrison and his government. The curse was that all future U.S. presidents, starting with Harrison, who were elected in a year whose last digit was a zero would die in office.
—Parade, *September 28, 1980*

William Henry Harrison: elected 1840, died 1841. Abraham Lincoln: elected 1860, reelected 1864, died 1865. James Garfield: elected 1880, died 1881. William McKinley: elected 1896, reelected 1900, died 1901. Warren Harding: elected 1920, died 1923. Franklin Roosevelt: elected 1932; reelected 1936, 1940 and 1944; died 1945. John F. Kennedy: elected 1960, died 1963.

President John F. Kennedy in 1961. Kennedy was the last to succumb to the supposed curse. *Library of Congress.*

What did each of these presidents have in common? They were elected (or reelected) in a year ending in zero—a remarkable coincidence. Even more remarkable is the fact that only one president who died in office was not elected in a year ending in zero. Zachary Taylor was elected in 1848 and died in 1850.

With a coincidence such as this, it is natural to look for a reason behind it—something that makes it less scary. The first person to remark on this series was none other than Robert LeRoy Ripley, known for his long-running *Believe It or Not* cartoon feature. In his 1934 book of the same name, a simple list of presidents from Harrison to Harding is given along with the date on which each was elected. The last line reads simply, "???.....1940." A later edition, published after Roosevelt's death, swaps out the question marks with "Franklin D. Roosevelt" and adds another line for 1960. Remarkably, little attention was paid to this during the presidential campaign pitting John F. Kennedy against Richard M. Nixon, and even after Kennedy's assassination, no great amount of ink was spilled analyzing this coincidence.

One of the earliest to write about it was William A. Clark, who in 1972 mentioned what he called the "20-year curse" but mentioned only how Richard Nixon had been in Dallas the day before Kennedy was shot. A few years later, John Holway, writing in the *Washington Post*, was the first to offer an explanation for the serial deaths: the stars. After noting that all four Aquarian presidents—FDR, Lincoln, McKinley and W. Harrison—had died in office, he added that they were "all victims of that 20-year curse, which astrologers insist has an astrological basis, having to do with the position of the evil star, Algon." There is no star named Algon, but Algol is known to be "the most unfortunate, violent, and dangerous star in the heavens," which may be what Holway was referring to.

In the run-up to the 1980 election, numerous articles referred to the remarkable run of bad luck exhibited by presidents elected in years ending in zero. In 1977, Arthur Schlesinger noted in his diary, in reference to the 1980 campaign, "Ted [Kennedy]? Can he be asked to affront the 20-year curse? Every President elected every 20 years beginning in 1840 has died in office." However, this did not appear in print until thirty years later.

One of the first to publish the story was Lloyd Shearer, of *Parade* magazine. Better known as Walter Scott, under which byline he wrote the long-running "Personality Parade," Shearer also occasionally wrote under his real name, and in the September 28, 1980 issue, he wrote up the usual list of dead presidents, then going on to wonder whether this was "the fulfillment of a cause laid upon William Henry Harrison and all subsequent U.S. Presidents elected in a year ending with a zero?" (It is his telling that leads off this section.)

Shearer gives no source for his story, and all subsequent tellings (including a whole book written shortly thereafter on the subject) simply refer to this column if they bother to give a source at all. The question then remains: Is there any curse spoken by Tecumseh that might be the original source for this tale?

Remarkably, the answer is yes. Tecumseh and his brother Tenskwatawa, better known as the Prophet, are both historical figures, and both spent much of the late eighteenth and early nineteenth centuries fighting against the encroachment of Europeans onto their ancestral lands. The issues came to a head in 1809, when William Henry Harrison, as governor of the Indiana Territory, negotiated a treaty that ceded a vast area of land to the new United States. Tecumseh went on the warpath, culminating in the 1811 Battle of Tippecanoe, which began with a sneak attack led by Tenskwatawa on forces led by Harrison. The battle turned out to be a disaster, as the American soldiers, warned by the noise made by their attackers, were able to muster a vigorous defense. Tecumseh, who was angry at his brother for botching the raid, died in another battle two years later.

Some thirty years later, English author George Jones wrote a play entitled *Tecumseh and the Prophet of the West*. In it, the story of Tecumseh's War is told in five acts. Act four begins with the aftermath of the Battle of Tippecanoe and Tecumseh's anger at his brother for losing to Harrison's forces. He works himself into a righteous rage and unloads on Tenskwatawa: "Redman! May the loud curse of Manitou be on thee! May his dreadful thunder crush forever thy false voice! May his fierce lightning flash forth, and cross thy path at ev'ry turn, that it may blind thee into darkest night!" It continues on in the same vein for a while, and Tenskwatawa responds by falling to his knees, cursed.

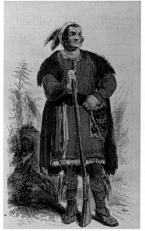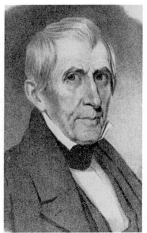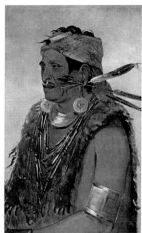

William Henry Harrison (center) with those who are said to have cursed him: Tecumseh (left) and Tenskwatawa. Circa 1841 lithograph of William Henry Harrison by Thomas Campbell. *Library of Congress.* Late nineteenth-century wood engraving of Tecumseh. *Library of Congress.* Tenskwatawa in an 1830 painting by George Catlin. *Smithsonian Institution.*

There is, of course, no indication that this scene eventually was transformed into a curse on President Harrison, especially since Shearer's column gives no source for his story, so there is no way to follow up on it.

Since this first appearance in print, the story has become more elaborate, and one 2003 book gives an exact quote for Tecumseh's curse: "Harrison will die, I tell you. And after him, every Great Chief chosen every 20 years thereafter will die. And when each one dies, let everyone remember the death of my people." Again, no source is given.

Of course, one of the reasons that so much effort has gone into trying to find a reason for this series is the apparent incredible improbability of it happening—or so it would appear. Looking at the numbers more closely, it becomes apparent that it is, after all, not completely impossible or even wildly improbable that a streak like this would happen. Given the 21 percent chance of a president dying during a term of office and a 58 percent chance of being reelected, there is a 7 percent chance that you will see a pattern such as the one we have here. Thus, the origin of the legend is simply a confluence of an unlikely—but not improbable—series of events coupled with the natural human tendency to find patterns and to want to ascribe some kind of greater meaning to those patterns.

THE CURSE OF SALLY HEMINGS

The zero-year curse gets a lot of attention, but there is a rule for the presidency that reaches back even further than Tecumseh's curse: the four-year curse. Every president who was elected in a year ending in four has not been returned to office in the year ending in eight.

Look at the record. Thomas Jefferson, in spite of having won his previous two elections handily, chose not to run again. Twenty years later, John Quincy Adams lost his reelection campaign to Andrew Jackson. James Polk declined to run again, dying only 103 days after his retirement from the presidency. Abraham Lincoln was of course killed before he could run again in 1868. Grover Cleveland, who had won a closely run election in 1884, lost in 1888, in spite of winning the popular vote. He would return to the presidency four years later. In 1908, Theodore Roosevelt, who had been elected only once after taking over the presidency after William McKinley's death, decided not to seek a second full term. Instead, he threw his support behind William Howard Taft, who won handily. Roosevelt returned to the presidential election in 1912, losing overwhelmingly to Woodrow Wilson. Calvin Coolidge, who won the election in 1924 after having taken over the office after Warren Harding's death, decided that five and a half years as president were enough, with the laconic quote, "I do not choose to run for President in 1928." Franklin Delano Roosevelt, who had already broken the unwritten rule that a president was to serve only two terms, won the 1944 election—his fourth—handily but died shortly after taking office in 1945. Lyndon Johnson, who had been thrust into the presidency after the assassination of John F. Kennedy in 1963, was easily elected president in his own right in 1964 but decided, like Coolidge, that five years in office were enough. Finally, the last two presidents elected in years ending in four, Ronald Reagan and George W. Bush, had both been initially elected four years earlier and thus found themselves term-limited in the following contest.

So why is it that winning in a year ending in four makes it so difficult to repeat four years later? There must be some reason, some curse, some overarching significance. And it all started with none other than the third president of the United States and the first to find himself out of office four years after winning in a year ending in four: Thomas Jefferson. Generally known as the most erudite man ever to inhabit the White House, the author of the Declaration of Independence and the man who rebuilt the Library

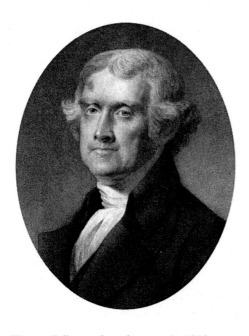

Thomas Jefferson, free of curses. An 1846 lithograph by Albert Newsam. *Library of Congress.*

of Congress, Jefferson had also been widowed at thirty-nine and later taken as his concubine one Sally Hemings, a woman thirty years his junior.

Hemings is known to have said, more than once, "Victory in four, defeat in eight," an African curse she had learned from her African-born grandmother, Susannah Epps. Jefferson's legacy to the United States also ensured that every president who followed would labor under the same curse. Thus did Hemings—long before DNA testing secured her place in U.S. history—ensure that she would not be forgotten two hundred years hence.

Of course, the above is utter nonsense. Yes, Sally Hemings (and her grandmother, probably named Susannah Epps) existed. But the rest is invented from whole cloth, and no doubt similar coincidences can be found for presidents elected in years ending in eight, two and six.

"GET DOWN, YOU FOOL!"

[Chief Justice Oliver Wendell Holmes] *told of a day long past when, Lincoln having come out from the White House to inspect the defenses, the task of piloting him had fallen to Holmes. Lincoln, too, wanted to know just where the enemy was, and Holmes pointed him out. The President stood up to look. Now, when standing up and supplemented by his high plug hat, Mr. Lincoln was a target of exceptional visibility. From the Rebel marksman came a snarl of musketry fire. Grabbing the President by the arm, the young officer dragged him under cover, and afterwards, in wave upon wave of hot misgiving, was unable to forget that in doing so he had said, "Get down, you fool!"*

*Admittedly, this was not the approved style for an officer to employ in
addressing the Commander in Chief of the armed forces of his country. The
youthful aide was more relieved, when just as Mr. Lincoln was quitting the fort,
he took the trouble to walk back. "Good-bye, Colonel Holmes," he said. "I'm
glad to see you know how to talk to a civilian."*
—*Alexander Woollcott in the* Atlantic Monthly, *February 1938*

In the two-hundred-plus years of United States history, only two presidents
have been exposed to enemy fire during a war. The first was James Madison,
who witnessed the Battle of Bladensburg during the War of 1812 and,
while probably not targeted, was within range of British guns during that
encounter. The second—and last, thus far—president so exposed would be
Abraham Lincoln, during the Civil War.

While the exact nature of fire that Madison endured has never entirely been
determined, the story of Lincoln's trips to Fort Stevens and exactly who said
what to him during those times has descended almost entirely into the realm of
myth. In spite of the enormous number of eyewitnesses to the event, almost none
agree on any details, and determining what really happens quickly becomes an
exercise in frustration, as each time a fact seems to be corroborated between any
two tellings, a third description contradicts the previous two.

Having said that, herewith a possible history of those three momentous
days when Washington, D.C.—and the president of the United States—was
under attack.

On July 10, 1864, with General Jubal Early's troops rapidly approaching the
capital, President Lincoln went out to view the state of the fortifications standing
between the Confederate general and Washington. What he saw was not
encouraging. While the forts themselves were well built and armed, the soldiers
manning them consisted mainly of a regiment of "one-hundred-day men" (i.e.,
men who had enlisted for exactly one hundred days and were thus about as
far from battle-hardened as you can get) from Oberlin, Ohio, the 150th Ohio
Volunteer Infantry. In particular, Fort Stevens, which overlooked Early's most
likely path into the city, was manned by Company K of this regiment.

It was clear that reinforcements were badly needed. Back at the White
House, Lincoln sent a telegraph to General Ulysses S. Grant requesting that
he send forces to help out in the defense of D.C. In response, Grant sent
elements of the Sixth Corps, under General Wright.

The next morning, with reinforcements on their way, Early arrived at
the outskirts of the city, in sight of the Capitol Dome and hard up against
Fort Stevens. He was required to rest his troops, as they had been marching

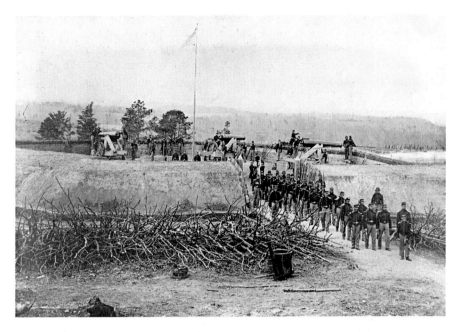

Fort Stevens in 1864. *National Photo Company Collection, Library of Congress.*

continuously for weeks, and many had broken into Postmaster General Montgomery Blair's house and helped themselves to his liquor.

Nonetheless, skirmishes broke out against soldiers who were posted in front of the fort. One of the skirmishers was John Amos Bedient of Company K, who managed to capture three prisoners. Bedient then attached himself to a Pennsylvania unit that had been sent out to harass the Confederate troops, but he returned to the fort after receiving a bullet through his hat. Back in safety, Bedient saw that President Lincoln had returned to the fort and was standing on the "bomb-proof," the storage area for munitions and the highest spot in the fort. Lincoln was entirely oblivious to the now–rapidly approaching enemy. Bedient thus called out, "President Lincoln, you had better get down—the Rebs will shoot you."

Lincoln obeyed, and shortly thereafter, bullets from Confederate sharpshooters begin flying over the heads of those in the fort. Not too long thereafter, the president left the fort and took his carriage down to the Sixth Street Wharf, where he welcomed the arrival of members of the Sixth Corps, come to shore up the defenses of the city. For his part, Bedient was sent to the hospital that had been hastily constructed in the barracks just behind the fort, suffering from a fever.

After a quiet night, during which the reinforcements took position all along the forts on the north side of the city, Early decided not to press his attack. It was now obvious to him that his forces were not enough to take Fort Stevens, let alone the city. The day was spent firing back and forth, with Confederate sharpshooters targeting anyone they could see in the fort, while K Company its their large ordnance at buildings from which the enemy was shooting.

Late in the afternoon, Lincoln returned once again to the fort. This time, he was greeted by Wright, and he climbed up onto the ramparts next to the general and Assistant Surgeon Cornelius Crawford to look over the battle. Wright pleaded with Lincoln to get down, but Lincoln did not allow himself to take cover until Crawford was injured by a bullet that had caromed off one of the large guns and Wright entreated him with the words, "Mr. President, I know you are commander of the armies of the United States, but I am in command here, and as you are not safe where you are standing, and I am responsible for your personal safety, I order you to come down."

About this time, Secretary of the Navy Gideon Welles arrived on the scene. He saw Lincoln "sitting in the shade, his back against the parapet towards the enemy." Right after this, the final push against Early began, with fire concentrated on the houses that the sharpshooters were hiding in and then members of the Sixth Corps who were out in front of the fort, driving Early's troops away and out of the city. During this phase of the battle, Lincoln continued to expose himself to fire, but only from behind the parapet, thus exposing far less of himself.

Is this what really happened? Probably not. Given the vagaries of memory and the length of time between the occurrences and when they were written down, it is quite probable that the events of those turbulent days were quite different. Numerous attempts to sort out the conflicting stories have produced as many different tales. Unfortunately, this is as good as the historical record will ever get.

What is remarkable is the number of eyewitnesses who describe the scene. Sadly, almost all of them wrote—or were quoted speaking about it—well after the battle. The only two who did write immediately after the events were not actually there for them. One is John Hay, Lincoln's secretary, who wrote (presumably the evening of July 11) that a "soldier roughly ordered him to get down or he would have his head knocked off." Though Hay does not mention his source for this, it sounds as if Lincoln himself passed on this version of the story. The following day, Hay simply reports that "a man was shot at his side."

The brass plaque displayed at Fort Stevens shows Abraham Lincoln under fire. *National Photo Company Collection, Library of Congress.*

The other person to write up his story immediately was Gideon Welles, whose story is above.

As to other eyewitnesses, most agree that it was General Wright who ordered the president down after the assistant surgeon was injured. The stories told of the previous day are considerably less coherent, and many conflate the occurrences of the two days. To weigh the facts and likelihood of their truth would greatly exceed the scope of this book. In fact, in 1948, John H. Cramer wrote a book, *Lincoln Under Enemy Fire*, that tried to do just this. Over 138 pages, Cramer is unable to ascertain what really happened in the fog of war surrounding those three momentous days.

Only one thing can be said with any certainty: it was not Oliver Wendell Holmes who ordered Lincoln down. On July 12, that honor almost certainly belongs to General Wright, while on the eleventh, when it was apparently done by some lower-ranking soldier, Holmes, as aide-de-camp to Wright, was not yet in the fort to order anyone down. Only late in life did Holmes insist that he had done so, and only to a few select people. Nonetheless, two of these spoke

with author and critic Alexander Woollcott, who wrote an article published in the *Atlantic Monthly* in 1937 in which he sought to clear the record—and assign the role of presidential lifesaver to the Supreme Court justice.

The argument made by Woollcott that Holmes had not previously reported his important role in this drama because others had taken credit for it and that only late in life did he feel it necessary to set the record straight is thin, particularly in light of the fact that at least two people, on two days, tried to get Lincoln to take cover. No, Holmes was reticent about telling the story because it simply was not the truth.

Stuck in the White House

William H. Taft got stuck in a White House bathtub, and it required plumbers with special cutters to get him out.
—Reading Eagle, *July 12, 1968*

William Howard Taft, twenty-seventh president of the United States, had a truly impressive résumé when he took office in March 1909. As a former secretary of war, governor of Cuba, Appeals Court justice and solicitor general, he was, in spite of never having held an elective office before, truly qualified for the job.

But today, nobody remembers Taft for the offices he held—even though he went on after his presidency to become chief justice of the Supreme Court. Rather, they remember him for his size. Which is not to say that he was not impressive; he was, after all, 355 pounds and six feet tall at the time of his election—a time when the average American stood only five-foot-eight. And he had a magnificent mustache. It is thus unsurprising that stories related to his girth remain popular. The details may change, as some sources have him stuck there on Inauguration Day, while others remark on the number of men needed for the rescue or the type of grease (usually butter) needed to free him. The idea that he was stuck on Inauguration Day is the most unlikely, as he did not move into the White House until after the ceremonies and would not have taken a bath after the late-night events that capped that particular day.

Furthermore, it is not just the White House where Taft was stuck. It appears that Taft was stuck in more bathtubs in more hotels than George Washington stayed in. Denver, Colorado; Erie, Pennsylvania; Nashville,

Taft at the White House with members of B'nai B'rith, who have just presented him with the medal he is wearing on his left lapel. *Harris & Ewing Collection, Library of Congress.*

Tennessee; Albuquerque, New Mexico—each claims to be the place where Taft got stuck. And it is always a bathtub, never a chair or automobile or any other constricted spot.

There is no doubt that Taft had issues with bathtubs. An article in the *New York Tribune* describes the results of his attempts to take a bath while in Cape May, New Jersey:

> *He failed to estimate even approximately the size of the average seashore hotel bathtub, and when he climbed into the tub, the water overflowed and trickled down upon the heads of the guests in the dining room. The entire resort, including Mr. Taft, is to-day laughing at the incident.*

Granted, this incident happened well after his presidency, but even before, he knew what he was getting into, and for a trip as president-elect to inspect the work on the Panama Canal, he had a special tub built and installed on the armored cruiser USS *North Carolina*. This tub was eventually moved into the White House and was thus waiting for him after his inauguration. Furthermore, multiple sources state that Taft knew exactly what was likely to happen in a normal bathtub and thus took showers whenever the possibility of his getting stuck presented itself.

So where did the story come from? The earliest telling of the story came in Irwin "Ike" Hoover's memoirs, published in 1934. Hoover had been chief usher in the White House for forty-two years, having served ten presidents. In his book, entitled *42 Years in the White House,* he made all sorts of allegations about the ten presidents he had served: Coolidge's breakfasts, the hijinks of the Roosevelt children and Taft's work ethic (or lack thereof).

Almost thirty years later, Lillian Rogers Park, who had spent almost fifty years in the White House, first when accompanying her mother, a White House maid, and later as a seamstress and maid in her own right, published a book entitled *My Thirty Years Backstage at the White House.* In it, she, too, retells the Taft bathtub story. As a young girl, she had snuck into Taft's bathroom and then climbed into the tub—not an easy proposition given that young Miss Rogers had braces on her legs due to a bout of polio she had suffered a few years earlier. Having closed her eyes, she thus was startled by the president when he said:

> *Well, well, well…what have we here, little lady? It isn't often, you understand, that I find such a treasure in my bathtub. Allow me to assist you. How do the newspapers do it? How in thunderation did they find out I got stuck in the bathtub and had to have a special one made? Oh, the cartoonist will have a field day with this one.*

Leaving aside the odd change in tense, the fact was that the newspapers of the time did not write about his being stuck in a bathtub. It was known that he had had a special one made, it is true, but only a very small number of papers bothered to mention it, and when they did, it was invariably simply a good-natured reference to its size and the fact that it would fit four average-sized men. In fact, the only time a bathtub was drawn in connection with President Taft was in regards to the Bathtub Trust, a group of companies engaged in the manufacture of plumbing fixtures that had conspired to fix

prices. In short, Park's fifty-year-old memory of something that happened when she was eleven was almost certainly colored by stories that she heard much later.

As difficult as it is to prove that something never happened, it seems quite clear that William Howard Taft was never stuck in a bathtub in the White House and that this story simply exists as a cautionary tale to the dangers of overeating.

FLYING THE FLAG

How can I tell if the President is in town? A flag flies over the White House when the president is in Washington.
—*Eve Zibart,* The Unofficial Guide to Washington, D.C., *2011*

One of the first questions tour guides get asked when in front of the White House is whether or not the president is currently there. For many years, this was indeed easy: just look at the flag above the White House. When the president left for more than a few hours, this flag would be brought down. This tradition started in the late nineteenth century and was followed for about twenty-five years. Woodrow Wilson decided to change this when he took office. He felt that the flag should fly from sunrise to sunset whether or not he was at home.

He was far from the first to feel this way. Others had said that, since the custom dictated that the flag fly over all government buildings every day, this should also apply to the White House. After years of protests from the Grand Army of the Republic, the organization of Union army veterans of the Civil War, and its auxiliary, the Woman's Relief Corps, Wilson relented. His compromise was to raise and lower the presidential flag from where it flew from the porte-cochere just below the main flag, which was affixed to a flagpole at the top of the White House.

Around the same time, the Capitol began flying flags on its east and west fronts twenty-four hours a day. This was due to the feeling during World War I that flags should fly continuously over public buildings in the capital. They later adopted the custom of flying flags above the wing of the chamber that was currently in session, a custom that continues today. Furthermore, to make it clear when work is being done, a light burns

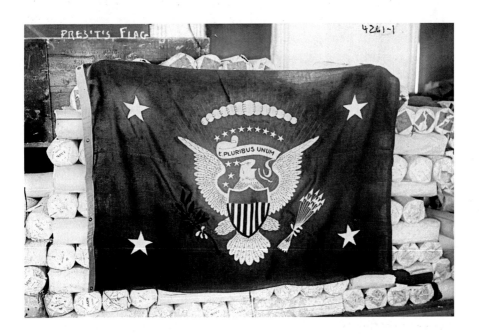

just below the Statue of Freedom at the top of the Capitol when either chamber is in session after dark.

After Wilson, the flag was once again lowered when the president was not in town, though in 1923, the National Flag Code was adopted. This changed very little, other than to codify the rules from before. The flag should be displayed from sunrise to sunset in good weather, though it could be displayed twenty-four hours a day if properly illuminated. Furthermore, the president could, at his discretion, declare locations that were to have flags flying at all times.

Thus, in 1948, by presidential proclamation, the flag was specified to be flown over Fort McHenry in Baltimore Harbor, in honor of the location of the star-spangled banner of Francis Scott Key's poem. Over the next thirty years, seven other locations were added to this list.

In 1949, the flag over the White House was removed prior to the two-year renovation during which the interior was gutted and rebuilt. During this time, the flag flew above Blair House, across the street, where Truman and his family lived.

On September 4, 1970, Richard Nixon added the White House to the list of places that flew the flag twenty-four hours a day, though by then, it already did so by custom. In short, there is no way of determining the president's location by looking at the top of the White House. If you need to know where he is, your best bet is to check the White House website and click on the link for "The President's Schedule," which lists his whereabouts each day.

Opposite, top: A 1923 photo of the eastern front of the White House showing the flag at half mast due to the death of Warren Harding. *National Photo Company Collection, Library of Congress.*

Opposite, bottom: The President's Flag as flown between 1916 and 1945. *George Grantham Bain Collection, Library of Congress.*

CHAPTER 4

The Sporting Life

Washington, D.C., while primarily obsessed with politics, is as sports-mad as any city. With a team represented in each of the four major leagues, as well as soccer and women's basketball, there is something for everyone to cheer for. Not surprisingly, there are legends revolving around sports as well.

STRETCHING TAFT

President William Howard Taft originated the seventh-inning stretch accidentally during a game in Pittsburgh. Taft stood up to stretch, and the fans stood in respect.
—Washington (PA) Observer, *August 25, 1964*

William Howard Taft loved baseball. Known as a good second baseman and decent hitter, he set aside his ambitions as a sportsman to concentrate on his studies and career. Nonetheless, he continued to enjoy the game, if only as a spectator. During the four years he served as president, he attended fourteen professional baseball games, the first exactly a month and a half after taking the presidential oath—and eleven days after being handed a pass good for entry to any American League game during the 1909 season.

It was the first time in memory that a president had attended a game. Theodore Roosevelt had never gone in his years in office, and while his

predecessor, William McKinley, was enough of a fan to invite the Senators to the White House shortly after taking office, he had then failed to appear at their game five days later, much to the disappointment of the assembled fans, which included some one hundred members of Congress. The disappointment was particularly keen in that McKinley was set to throw out the first pitch, something he had done five years earlier in Columbus while the governor of Ohio. McKinley then failed to attend any other games—a failure partially attributable to the fact that there was no Washington team for part of his presidency. Since 1901, however, baseball was again played in the nation's capital, first as the Senators and, since 1905, as the Nationals. The name change was apparently an attempt to transform the team's losing ways.

In spite of the Nationals' loss to the Boston Red Sox on April 19, 1909, Taft enjoyed the game immensely, sharing a bag of peanuts with Vice President James S. Sherman, hoping that it was not his presence that had caused the Nationals to lose and refusing his Secret Service agents' entreaties to leave before the end. It was thus unsurprising that Taft did not wait long for his second game, attending a Pirates-Cubs game in Pittsburgh a little over a month later.

During this game, the germ of the legend was sown. An article from Dubuque, Iowa's *Telegraph-Herald* tells the story: "In Pittsburg's half of the 'lucky' seventh, the president set the crowd to cheering by standing 'for luck' with the rest of the great crowd." However, the reason for this was not discomfort, as many versions of this tale have it, or, as is the case today, a chance to stretch but rather a tradition going back many years set to encourage the home team by having its fans stand during its turn during the seventh inning. In this case, the support worked—to a point. The Pirates managed to tie the score, and it was not until the twelfth inning that the Cubs came back to win the game, 8–3.

The "lucky seventh" was a tradition going back at least to 1887 and was usually seen as a Washington-only phenomenon. A 1905 article in the *Post* attempted to get to the bottom of it, but other than noting that seven "is a mystic, cryptic, tricky number that has made all sorts of trouble in the world," as well as listing all sorts of things that come in sevens—deadly sins and virtues, to name two examples—it did little to explain the matter. Most likely, the seventh inning is simply early enough in the game that the home team, if it is losing, still has a chance of coming back.

By 1905, the New York papers were already referring to the seventh inning as "stretching time," so clearly that particular inning was used for more than just cheering by then. In short, Taft was not setting any precedents when

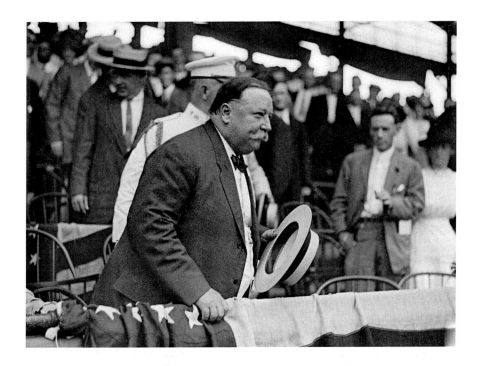

Above: Taft standing at the last baseball game he attended as president, August 13, 1912. *George Grantham Bain Collection, Library of Congress.*

Left: William Howard Taft throwing out the first pitch at a Nationals game, April 14, 1910. Picture published in the *Washington Times. Library of Congress.*

he arose that day in Pittsburgh. Baseball history would have to wait almost another year for Taft to make his mark.

On April 14, 1910, the *Washington Times* trumpeted the opening of the baseball season on its front page. Chiefly among the excitements to be expected that day was the fact that the president, "the greatest baseball enthusiast who has ever had the right to smoke in the parlor at the White House," would be attending the game and that he "would throw out the first ball." No president had ever done this, as this duty was usually reserved for "an ex-president of the club, a Commissioner, or one of the leading Fourth of July Democrats in whatever city the opening may take place."

In spite of this buildup, the *Times* did not waste much ink on describing the president's throw the next day. Instead, after briefly mentioning his presence, it went on to describe the fine performance on the part of the Nationals, which defeated the Philadelphia Athletics behind the indefatigable arm of Walter "Big Train" Johnson. Fortunately, the *Washington Herald* was more aware of the historic nature of this day, describing how Taft, from the box he occupied with Mrs. Taft, threw "a nice white, shining sphere into Walter Johnson's hands while the crowd roared its approval."

Since then, the Opening Day ceremonial pitch by the president has become an institution. Every president since Taft has thrown an Opening Day first pitch—except Jimmy Carter, who, instead threw out the first pitch at the first game of the 1979 World Series.

A Cuban Senator

[Fidel] *Castro…had spent several weeks at a Washington Senators "tryout" camp in 1944, soon after having been named the top high school athlete in Cuba.*
—*Van Gosse,* Where the Boys Are, *1993*

This story is told for many purposes. Some use it to show Castro's initial interest in and lack of hate for the United States, while others use it to show how history can turn on the slightest twist of fate, for had Castro been a slightly better player, he might have ended up in the United States, not only playing baseball for good money but also in the capital of the hated capitalists.

Many versions of this story exist, including one that has the New York Yankees being the interested party. Others claim that Castro himself wrote

to Clark Griffith asking for a tryout. Yet another story has Castro turning down a $5,000 offer from the New York Giants in favor of studying law.

What is true is that Castro is well known as a baseball fan and—to a lesser extent—player. Until age stopped him, he would don a uniform marked "Barbudos"—the bearded ones—and play against various Cuban teams. He had a brief career playing as a student at the University of Havana. At the same time, a baseball scout named Joe Cambria had basically moved to Cuba in order to find new and talented players for the Washington Senators. Cambria was well known for his efforts, and Whitney Martin, an AP sports columnist, wrote of him in 1940, "They poke a lot of fun at Uncle Joe. They say he chases his prospects up trees and lassos them, or smokes them out of their caves; that every time a young fellow in Cuba hits the ball out of the infield, he hears about it."

On January 8, 1959, Castro's army marched into Havana. A little over a month later, he was sworn in as prime minister. Just under three weeks later, Joe Cambria mentioned that he had given Castro "a long look and then decided he'd never get higher than Class B ball—or at best could struggle up to A ball." In other words, long before Castro had become the bête noire of the United States, Cambria mentioned having watched him. Much later, Cambria would expand his analysis of Castro's talents, claiming he had a decent curve ball but "not much of a fastball."

In his 1999 book *The Pride of Havana*, an award-winning book on baseball in Cuba, Yale literature professor Roberto Gonzalez Echevarria disputes Cambria's story. Having gone through all the many newspapers reporting on the Havana baseball scene in the 1940s, he found exactly one reference to an "F. Castro" pitching a game: a 1946 intramural game between the law and business schools, which Castro's team lost.

Whatever the truth of his other allegations, Cambria did once offer Castro the chance to play with the Senators. While Castro was visiting the United States as part of a charm offensive in April 1959, Cambria asked him whether he would like to come pitch for the Senators the next day. Castro declined this kind offer, not the least because he would have been facing the New York Yankees and Mickey Mantle.

In short, there is a very small grain of truth in the story, though nothing to indicate that Castro was almost signed by any team. So did Cambria mention his analysis of Castro's potential to others because he felt that he had to know every Cuban baseball player, even one who had only pitched intramural ball at Havana University? Or did he really watch him? Sadly, Joe Cambria took the answer to this question to the grave when he died in

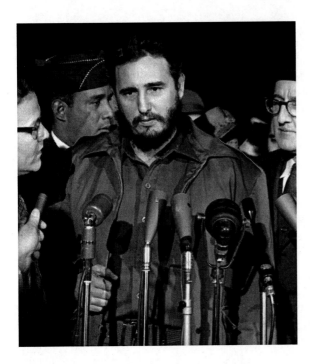

Fidel Castro at the Military Air Transport Service Terminal, National Airport, Washington, D.C., after his arrival in the United States on April 15, 1959. *Library of Congress.*

1962. Certainly, he insisted to the end that he had watched Castro, and he elaborated the story as he went. Since then, others have molded the story for their own purposes and in doing so have considerably raised Castro's talent on the baseball field.

READING THE FOOTBALL RESULTS

Every time the Redskins win their final home game before a presidential election, the candidate representing the incumbent party remains in office. Every time they lose, the incumbent party's candidate loses as well.
—Washington Times, *November 3, 2008*

On October 30, 2000, sports analyst Steve Hirdt was sitting in his hotel room in Washington, D.C., searching through piles of statistics for a few nuggets that he could pass on to the commentators for the next day's *Monday Night Football* game, featuring the Washington Redskins and the Tennessee

The Washington Redskins training camp, August 1937. In the air are three rookies. *Harris & Ewing Collection, Library of Congress.*

Titans, when he noted a remarkable coincidence. Many years later, he told ESPN's Bill Hofheimer how he came to make his discovery: "I started looking through the Redskins' press guide where they list all the scores in the back. I was making a list of the last home games before the election because that was the game we were covering. I tried to align it with the Democrats or the Republicans and then looked at the incumbents."

It was then that Hirdt realized that the Redskins victories all aligned with the incumbent party retaining the White House. This remarkable coincidence stretched back all the way to 1940, when their win a day before the election prognosticated Franklin Delano Roosevelt's reelection for a historic third term. Although the Redskins had existed prior to the previous two presidential elections, they had not moved to Washington until 1937; thus, 1940 was their first election year as the local team. Hirdt convinced the producer and announcer for that night's game to run this piece of trivia during their broadcast. The Redskins proceeded to lose, thus predicting that George W. Bush would win the presidential election.

The very next day, CNN included the trivia as part of its presidential predictions wrap-up. They concentrated on two predictors: the Dow Jones Industrial Average, whose rise in the August to October time span foretold a Gore victory; and the Redskins, whose loss pointed to the opposite result.

In the uncertainty of the thirty-seven days following the election before Bush was finally declared the victor, no further attempts to divine any particular meaning in this series of Redskins wins and losses were made. In fact, until 1996, it was not just the last home game but the last game that the Redskins played before the election that predicted the results. However, a loss to the Buffalo Bills two days before Bill Clinton won reelection had broken that streak. Since they had won their last home game, the home-game predictor remained alive (remarkably, from 1940 until 1996, the result of the last game and the last home game being the same, though five of fourteen games were not the same game, i.e., the last home game was not the last game played).

Four years later, the Redskins rule was well known, and when the Redskins played their final home game against the Green Bay Packers on October 31, even fervent Redskins fans supporting John Kerry were rooting against their team. At election offices across the region, a great surge of hope came in when it was announced that the Redskins had lost, predicting a Kerry victory.

It was not to be. Two days later, George W. Bush beat his challenger by several million votes. The Redskins rule, as it had been called, was no more—just four years after it had been noticed. Hirdt suggested that there needed to be a modification, that the fact that Bush had won the presidency in 2000 while losing the popular vote meant that, four years later, in fact, Gore should be treated as the incumbent and thus the Redskins loss meant that the challenger, Bush, would win. Few accepted this rationale, and though the rule gets trotted out every four years, its failure in 2012 to predict Barack Obama's reelection put the rule into the same bin that so many other rules have been put into over the years: just another historical relic.

Randall Munro, creator of the comic *XKCD*, famously skewered this (and all other) attempts to predict presidential races by looking at external factors in a strip that ran just before the 2012 election. He found a rule for every single race that had held up until then but was then broken. Some are slightly more ridiculous than others: "1912...After Lincoln beat the Democrats while sporting a beard with no mustache, the only Democrats who can win have a mustache with no beard...Wilson had neither." The point was clear: as long as you have enough events and cast a wide enough net, you will find these coincidences. That the Redskins are a D.C. institution just makes it all the more fun.

CHAPTER 5

All Around the District

Washington, D.C., is far more than just the federal government and its agencies. It is also a city with hotels, homes, cemeteries and public transportation, all of which have generated their own tales.

THE HOMESICK WIFE

To stave off [D.C. contractor Samuel Gessford's] *young wife's homesickness for her native Philadelphia, he took her to Europe while he erected, across from their Capitol Hill home, five row houses in the style of those in her home town. They returned to Washington late at night, and when she looked out her window the next morning, she saw Philadelphia.*
—*Stuart E. Jacobson,* Only the Best, *1985*

The Capitol Hill neighborhood in Washington is known for its architecture, the remarkable variations on a theme. Most of the houses were built between 1880 and 1920, with the pre-1900 houses tending to the Victorian, with bay fronts, ornate brickwork and cast-iron steps leading to the front doors, while the later ones have flat fronts with porches connected to the street via wooden

or concrete steps. There is one famous row of houses that stands out from this. Running north along Eleventh Street SE from Independence Avenue are fourteen houses that were clearly all built at the same time. Three stories high, flat-fronted and with pressed brick, they have marble steps leading to their front doors. They look much more like houses that one would see in older cities, especially Philadelphia, and it is from this appearance that this section of houses has been given its name: Philadelphia Row.

Unsurprisingly, for a set of houses that are so different from others in the neighborhood, a story has grown up around them. According to the legend, they were built in order to assuage the homesickness of the wife of the builder. While she took a long trip to Europe, he had them built across the street from their home in D.C., and when she returned home, he brought her into their house in the dead of night, by the back entrance, so that when she awoke the next morning and looked out, it would appear that she was back in her native Philadelphia.

Unfortunately, almost nothing of this heartwarming story is true. The only part that is true is that Stephen Flanagan, the builder of Philadelphia Row, was indeed from that city. There is no indication, however, that he ever actually moved to D.C. Instead, he and sixteen others founded the Washington Land and Building Company in 1866, and it was this company that bought considerable tracts of land to the east of the Capitol in hopes of cashing in on the post–Civil War building boom in the city.

Flanagan's wealth stemmed from shipping, especially a steamship line that he began in March 1866 and of which he was president. His holdings in the capital were thus always secondary, and after the failure to sell the fourteen houses built on Eleventh Street, he built no further and sold the rest of his holdings in 1889, his dreams of getting rich on Capitol Hill real estate as dead as those of so many others before him.

The name of the builder is also confusing. A man named Gessford was indeed a builder on Capitol Hill, though long after Philadelphia Row had been built. In fact, in the 1880s, Gessford was one of the most prolific builders on the Hill, though he, too, ended up losing all his money in the economic downturn in 1893, shortly before losing his life. However, his first name was Charles, not Samuel.

Where the story of a homesick wife originated is unclear. The earliest publication seems to be Stuart Jacobson's coffee-table book, *Only the Best*, which celebrates great gifts. The book contains text—quoted at the top of this section—by Jill Spalding and photographs by Jesse Gerstein; Jacobson's contribution appears to have been "organizational." From there, the story has

Above: View of Philadelphia Row on Eleventh Street SE. *Photo by Maria Helena Carey.*

Left: Entrances to two of the houses on Philadelphia Row. *Photo by Maria Helena Carey.*

crept into books on local history and tourist guides. As a story about the love of a man for his wife and his deep-seated wish to keep her happy, it will probably continue to circulate forever, in spite of it being almost completely made up.

The "Scaly Serpent of the Lobby"

President Grant was not a big fan of the White House, and he liked to get out and have a cigar in the evening. He would go to the lobby of the Willard Hotel almost every night for a cigar and drink. People would wait in the lobby until he got there and then talk to him informally about what it was they needed. They became known as lobbyists.
—USA Today, *February 14, 2006*

Lobbying a politician for personal favors or in return for hard cash is an old and established tradition in Washington, and it has been excoriated as a perversion of the political process for almost as long. One of the more colorful descriptions of the process comes from a 1906 book by Emily Edson Briggs, in which she writes, "Winding in and out through the long, devious basement passage, crawling through the corridors, trailing its slimy length from gallery to committee room, at last it lies stretched at full length on the floor of Congress—this dazzling reptile, this huge, scaly serpent of the lobby."

Which lobby, exactly, is meant in this screed is the subject of one of the more pervasive D.C. urban legends. While the verb lobby is, at this point, almost completely divorced from the original noun, the question remains how this transition came to be. One of the stories is told by the people at the Willard Hotel.

The Willard is located just a few blocks from the White House and has a long and distinguished history since its founding in 1841. The source for this story is invariably the book *Willard's of Washington: The Epic of a Capital Caravansary*, published in 1954. It, in turn, quotes the *Washington Critic* of November 10, 1869, as writing:

President Grant, on his evening walks to Willard's, dresses in sober black and wears a silk hat. He always walks slowly, with one hand in his breeches pocket, and the other holding his cigar or thrown behind his back. He looks straight ahead or at the ground, and never notices anybody.

Civil War–era drawing of the gentlemen's parlor, reading and sitting room of the Willard Hotel. Drawn by Thomas Nash. *Cabinet of American Illustration Collection, Library of Congress.*

Unfortunately, the author seems to have taken some liberties with the original text. While some of these words did indeed appear that day in the *Critic*, the form they took was as follows:

> *President Grant takes a long walk early every morning, either toward the Capitol along F Street or toward Georgetown. He walks slowly with one hand in his breeches pocket, and the other either holding a cigar or thrown behind his back, and looks straight forward or on the ground, never noticing anybody. After dinner, he rides out.*

No mention of the Willard or, for that matter, any other particular after-dinner destination. Furthermore, given that there is only about a block between the White House and the Willard, there is no reason to believe that he would ride out to get there.

That Grant spent time in the Willard is unquestioned. In the spring of 1864, Grant and his son arrived at the hotel when he was there to receive his commission as lieutenant general. The desk clerk did not recognize the dusty

Female lobbyists accosting a member of Congress. 1884 drawing from *Frank Leslie's Illustrated Newspaper. Library of Congress.*

stranger across from him, who seemed just another quiet, tired traveler in search of a bed. Only after reading his entry in the register did he realize that across the desk from him stood the man generally regarded as the savior of the Union. The rest of Grant's visit was marked by a far more boisterous reception.

Grant returned to the Willard later in life. The *Washington Evening Star* reported that Grant and his wife tendered a dinner for their daughter and her husband on April 23, 1877—a month after Grant had left office. Otherwise, the thirty-one-volume *Papers of Ulysses S. Grant* has only four references to the Willard during his time in office and only one that places Grant himself in the vicinity. In a missive by a Dr. Anthony Ruppaner, he complains that a letter he had shown Grant while "at Willard's or near there" had not been accepted.

In short, Grant's connection to the Willard—and thus, its lobby—was far more tenuous than generally accepted. But what about the word "lobbyist"? Did that have any connection with either Grant or the Willard?

Again, the evidence indicates the opposite. The term "lobbyist" appears in print as early as 1856, and by 1860, a character in the story "The M[ember of] C[congress]'s Christmas Tale and the Lobby Member's Happy New-Year" calls another an "incorrigible lobbyist" who has "haunted Washington and pestered members" for many years. An even older term, "lobby agent," goes back to at least 1841.

In fact, the Briggs quotation above was published in February 1869, well before Grant took office on March 4, 1869. In short, neither Ulysses S. Grant nor the Willard is in any way responsible for the word "lobbyist."

LEADING THE "SAD LITTLE PARADE"

Marion Kahlert, a ten-year-old girl who died beneath the wheels of a Hineberg's Bread truck in 1904, is memorialized [in Congressional Cemetery] *as the District of Columbia's first traffic accident.*
—Baltimore Sun, *April 1, 1979*

Traffic accidents cause about 2 percent of all deaths in the United States. Washington, D.C., is actually one of the safer places to be in a car, but nonetheless, dozens of people die in traffic in the city every year and have done so since the beginning of the late nineteenth century, when automobiles began their steady march toward ubiquity.

Along the way, there had to be a first victim. For the world, it was Mary Ward in Ireland in 1869. For the United States, it was Henry H. Bliss, run over by a taxi in New York City in 1899. For Washington, D.C.? Well, the story was always that it was Miss Marion Ooletia Kahlert, whose bereaved parents built a beautiful, life-size statue as a final memorial to her. It shows Kahlert as she was just before she died, one hand leaning on a short column, wearing a proper dress with ruffles, button shoes and with her hair in ringlets. Her memorial stands over her grave on the far western edge of Congressional Cemetery, a cemetery two miles southeast of the Capitol and famous for the many rich, powerful and important people who have been laid to rest there.

Marion Kahlert made her way into the history books in 1955, when a Mrs. Detwiler wrote a guide to Congressional Cemetery, in which she wrote, "When the newspapers of 1904 recorded Washington's first traffic fatality caused by a new-fangled automobile, they could not then foretell the tragic

Left: Marion Ooletia Kahlert's gravestone at Congressional Cemetery. *Photo by Maria Helena Carey.*

Below: Detail of a statue of Marion Ooletia Kahlert. *Photo by Maria Helena Carey.*

URBAN LEGENDS AND HISTORIC LORE OF WASHINGTON, D.C.

and endless line of victims who were to follow. Marion Ooletia Kahlert, ten years old, met her death on an October day."

Over the years, details were added to the tale, including the detail that it was actually a bread truck that caused poor Miss Kahlert's death. There was no Hineberg's bakery in D.C. in 1904, though there were at least two bakeries run by brothers named Meinberg. Other sources claim it was a milk truck from an unnamed company. Yet another version adds the poignant detail that she was "carrying a doll in her arms when she was killed."

Along the way, nobody bothered to do what Lisa Rauschert, head of the history department at Georgetown Day School, did: look up the records of Kahlert's death. In 1999, Rauschert decided to use Kahlert's death as an object lesson for her students, and they went through newspaper microfilms from the days following her death on October 25, 1904. Neither the *Washington Post*, the *Washington Times* nor the *Evening Star* listed her cause of death, so Rauschert went to the vital records office to retrieve the almost-one-hundred-year-old death certificate. It listed Marion Kahlert's death as acute tubercular nephritis leading to kidney failure—a doubtless painful way to perish, but one that had afflicted mankind for thousands of years. When *Washington Post* reporter John Kelly heard of this, he knew it was time to set the record straight. He wrote two columns in which he delved into poor Miss Kahlert's fate—as well as determining the actual first automobile fatality in the District.

On September 22, 1904, Robert Marshall, a newsboy, having just bought a bag of peanuts, stepped off the curb of Fifteenth Street near New York Avenue and was struck by the wheel of a supply wagon belonging to the Washington Electric Transportation and Vehicle Company. The boy fell to the ground and was run over. The driver, one Jacob Thomas, stopped the car as quickly as possible, but when he saw that a policeman was already engaged in calling an ambulance, he drove the car back to its garage and went home. Marshall was taken to Emergency Hospital, but it was too late—he was dead of a fractured skull. Thomas was found at his home and arrested but was released two days later after the coroner's jury rendered a verdict of accidental death. Marshall's name reappears in the newspapers the following year when his mother sued the owners of the car that ran down her son. The result of this trial, much as the final resting place of young Marshall, was never published.

According to Sandy Schmidt of Congressional Cemetery, the first time that the rubric "Run over by automobile" is listed in the D.C. death statistics is 1904, and there is only one that year: Robert Marshall. Thus, this young

newsboy is clearly the District's first automobile fatality, and it is he, not Miss Kahlert, who, in the poignant words of Mrs. Detwiler, leads the "sad little parade of children into infinity beneath the wheels of the horseless carriage."

THE CABBAGE MEMO

Not long ago, FDIC Vice-Chairman John M. Reich said that there are 65 words in the Lord's Prayer, 286 words in the Gettysburg Address, 1,322 words in the Declaration of Independence and 26,911 words in the federal regulation governing the sale of cabbages.
—speech by Representative Tiahrt, July 14, 2005

The point that Reich—and Representative Todd Tiahrt, who was quoting him on the floor of the House—is making is clear: the only thing the government is capable of producing is impenetrable word salad. Instead of finding solutions, involving the government will only make a situation more complicated.

Reich was not the first to point out the discrepancy between the words needed to, say, dedicate a new national cemetery versus those needed to implement a federal regulation. In fact, as early as 1943, people were making this comparison and, just as in Reich and Tiahrt's case, getting the number of words in the various documents wrong.

To be entirely pedantic here, there are 66 words in the King James Version Lord's Prayer, 267 in what is considered the most accurate version of the Gettysburg Address and 1,338 in the Declaration of Independence.

But what about the cabbage memo? Did this actually exist? And did it have 26,911 words? As so often in these cases, there is indeed a kernel of truth to the matter, and fortunately, Gary Alan Fine and Barry O'Neill, professors at Northwestern and UCLA, respectively, delved deep into the archives to find it in order to publish it in the *Journal of American Folklore*.

Fine and O'Neill discovered what they believe is the original source of this legend. On August 19, 1943, the Office of Price Administration (OPA) released Maximum Price Regulation number 455, as well as a press release explaining it. Section 4, subparagraph (a)(2) of the regulation declared that "'cabbage seed' (Brassica capitata) is the seed used to grow cabbage."

The OPA, which was in charge of making sure that sellers did not use World War II as an excuse to gouge consumers, had noticed that with the

A cow eating cabbage in Texas, 1939. Previous to the United States entering World War II, cabbage was so cheap that it was used for animal feed. *Farm Security Administration/Office of War Information Collection, Library of Congress.*

loss of Holland as a source for cabbage seed, it had become easy to corner the market in the United States and that someone had indeed done so. The cost of the seed had gone up tenfold—an intervention was necessary.

In writing the regulation, Scovel Richardson, an OPA attorney, was told to define every term used, even such self-evident words as "cabbage seed." It did not take long for people to take note of this, and on August 20, the United Press sent around a short item to its member newspapers poking fun at these new releases. After remarking on the press releases' length—2,500 words—the piece finished by quoting Section 4, subparagraph (a)(2).

At least United Press had its facts basically right. It managed to properly assign the definition to the regulation, as opposed to the press release, and it poked fun at a definition that even Richardson had felt was overkill. Others were not quite so careful, and thus did the story begin to mutate.

It was not long thereafter that a new twist was added to the telling of the tale, though who added it is unclear. A wire arrived at the OPA contrasting the lengths of the Ten Commandments, the Lord's Prayer, the Declaration of Independence and the Gettysburg Address with the 2,611 words "it took an OPA lawyer…to say cabbage seed (Brassica capitata) is the seed to grow cabbage." By now, the mutation was almost complete. While others, including

91

Reader's Digest, continued to poke fun at the unnecessary definition, the contrasting-length fable began a long and seemingly unstoppable run. Senator Charles Tobey of New Hampshire quoted a variant—in which he managed to have the OPA raising the price of cabbage seed—during a committee meeting in December 1943. In doing so, he made the regulation not only verbose but also misguided, and thus a perfect target for those of an anti-regulatory bent.

Maximum Price Regulation 455 was revoked in 1946, but that did not stop people from using it as a rhetorical punching bag. Somewhere in the early '50s, it mutated one final time, with the length of the regulation now increased to 26,911, and it is this variant that remains the most popular today, in spite of it being debunked as early as 1965 as the "Great Cabbage Hoax." Dozens of books have republished the tale uncritically; it has made the jump across the Atlantic, where it describes the length of a European Union directive; and any number of politicians have quoted it, including Ronald Reagan. The last, it must be said, at least made some attempt to determine its veracity, adding when he spoke to the National Association of Manufacturers, "Possibly, the story is more folklore than fact" but then undermining his case by stating, "I think it's one case where a bit of folklore can convey a lot of wisdom."

It should be pointed out that whole books have been written on the meaning of the Lord's Prayer, the Gettysburg Address and, of course, the Declaration of Independence, while nobody has ever questioned the exact meaning of the statement that "'cabbage seed' (*Brassica capitata*) is the seed used to grow cabbage."

A METRO STOP FOR GEORGETOWN

When D.C. built the Metro in the 1980s, local residents vetoed a Georgetown stop, condemning future generations of visitors to shuttle buses and the endless pursuit of parking.
—Lonely Planet Washington, D.C., *2007*

Washington's Metro system of underground trains is a boon to tourists, who use it to get around the city without having the hassles of driving or, even worse, parking. There is just one great problem: there is no stop in the old Georgetown neighborhood, and thus visitors must either walk from Foggy Bottom Metro or use buses to get to this part of D.C. This is unfortunate, as

Georgetown has much to offer: the C&O Canal, the Old Stone House, the Exorcist Steps, the university and a plethora of shops and restaurants. Even more annoying is that there seems to be no real reason for the lack of a stop. The Metro line connecting Rosslyn in Virginia and the Foggy Bottom station essentially goes right under at least a corner of Georgetown, so why did the officials planning the station not simply add one there? Legend has it that there was indeed a stop planned there, but this stop was nixed by residents who were concerned either by the damage done to their historic homes by the Metro or by the fact that this new mode of transportation would bring in undesirables to their neighborhood. And by this, they were not referring to tourists. The latter reason is often given by those seeking to portray Georgetown residents as hidebound and reactionary, trying to stem the tide of change in a city that has personified change for over two hundred years.

However, neither explanation holds water. The simple truth is that there never really was any plan to add a Metro stop in Georgetown. This came from a number of reasons. The first was that Metro, when it was being planned, was to be a very different beast than it has turned into. D.C. officials saw Metro as primarily a commuter rail system. In other words, its job was to move people from their homes in the suburbs around Washington to their jobs in the center of the city. It was really a continuation of the plan to drive highways through the city for the ease of commuters, a plan that had been thwarted by determined residents and historical preservationists in the 1950s and '60s. Thus, suburban stations were built such that they were surrounded by large parking lots, allowing each commuter the opportunity to drive to the train and then make it into the city without further delay. Georgetown did not fit into this model, as few residents commuted into the city and fewer commuted out of it. As a result of this single-minded objective to moving commuters, it actually took significant effort to include the one Metro stop used by almost every tourist who comes to the city: the Smithsonian station.

Other objections to having a Metro stop in Georgetown included the aforementioned possible damage to houses, as the line would have to be routed under them rather than under streets to make the sharp turn necessary to bring the train from Rosslyn to Foggy Bottom. Furthermore, given that the train had to pass under the Potomac right before it reached Georgetown, the station would have to be built prohibitively deeply in order to work at all. Although it is likely that these issues could have been resolved had there been a push to connect Georgetown to the Metro, the fact is that there never was that push.

In spite of this lack of interest in building, one thing is true: there was opposition to a Georgetown Metro station. Bob Levey, *Washington Post*

A Metro train entering the tunnel at the proposed location of the Oklahoma Avenue Metro station. *Photo by Maria Helena Carey.*

reporter, found a position paper written by the Citizens Associations of Georgetown in which they state that "a line through Georgetown would lead to nowhere but deficits." Even in 1977, when Metro was about to open all across the District to great acclaim, the residents of Georgetown saw no reason to modify their initial reaction. To them, Georgetown's isolation was to be cherished, not changed.

What is interesting is that there was one Metro stop that was stopped by local opposition. It was nowhere near Georgetown, however, being located all the way across the city on the banks of the Anacostia River. The Oklahoma Avenue stop was to take advantage of the enormous parking lots that surround Robert F. Kennedy Memorial Stadium. In accordance with the planned use for Metro, these lots were to store the cars of thousands of commuters every day. Residents who lived nearby protested that they had no interest in a subway running directly in front of their houses, a position they managed to convince the powers that be to be correct. Today, Metro trains run a few hundred feet from their houses, descending underground in the middle of the parking lots. The closest stop is almost a mile away, on the other side of the stadium.

Finally, one last mistake in the quote initiating this section should not be left unaddressed: the D.C. Metro was planned in the 1960s and built over the next decade and a half. It first opened in 1976. Although some stations were opened in the 1980s, the bulk of those were line extensions outside the District.

Capitol Tales

S tanding high above the National Mall, on the hill that Peter L'Enfant proclaimed to be the "pedestal waiting for a monument," stands the Capitol. For over two hundred years, it has been the scene of important debates, votes and speeches. It has also collected around it numerous tales going back all the way to the first—and only—president to have returned to Washington as a member of the House of Representatives: John Quincy Adams.

EAVESDROPPING IN THE HOUSE

Standing by the bronze marker [marking the location of John Quincy Adams's desk], *it is possible to hear a faint whisper from another point 50 feet to the east. Thus it was that in his early days as a Representative, Adams sat at this spot and listened to his opponents plotting against him on the opposite side of the large Hall. His ability to anticipate opposition confounded his adversaries until the secret of the "whispering stones" was discovered. At this juncture, heavy draperies were hung between the pillars in an effort to stifle the loud whispers, but it was to no avail.*
—*Emery L. Frazier,* Our Capitol, *1963*

It's a beautiful image: the wily old congressman and ex-president subverting his young and energetic colleagues while apparently sleeping—the eternal battle between youth and age incarnate in one fell swoop.

Too bad that almost none of it is true. There is, however, enough truth in the story to make it worthwhile to delve more deeply into its origins.

Soon after the House of Representatives wing of the Capitol was rebuilt in 1819 and the members had moved back in, they discovered that the acoustics of the hall in which they were to do business were absolutely miserable. Echoes made it very difficult to understand whoever was speaking, and the record of the time includes many instances in which words are garbled or there are requests for the speaker to repeat himself.

Numerous attempts were made to alleviate this state of affairs, including moving the speaker's chair and thus the whole layout of members' desks, but real relief was not found until Congress moved into its new, larger home in the south wing of the Capitol in 1857.

The old hall fell into disrepair, and in 1864, Representative Justin Morrill of Vermont complained that it was "draped in cobwebs and carpeted with dust, tobacco and apple [scraps]." The last came from the stalls that had been set up in the hall, selling a wide variety of things, including, as British novelist Anthony Trollope noticed when he visited the Capitol in 1861, "very bad tarts and gingerbread." Morrill's suggestion was that the old hall be turned over to the National Statuary collection, where each state of the Union could send two statues of famous residents. With this new purpose, the old hall became a magnet for tourists visiting D.C., and the guides who took people through it noticed that it had an interesting property: there were a number of pairs of places wherein if one person whispered, they could be heard clearly in another part of the room, quite a distance away. Tour guides would have their charges stand near one of the pilasters at the rear of the hall while they stood at another one. The guide would speak, and if doing so clearly and distinctly enough, the words could be understood by their charges, standing almost one hundred feet away. Standing in another place and speaking would make it appear that the voice was coming from above a different spot, and some would wait for unsuspecting victims to pass by the latter spot before saying something like, "Look out! I am going to let this drop!"

Most descriptions of these phenomena compared them (usually critically) to other well-known whispering galleries, such as the one in St. Paul's Cathedral in London or the Hall of Secrets in the observatory in Paris. The shape of the roof was known to make it possible, so that when in 1901, the state of the hall, now almost one hundred years old and showing its age,

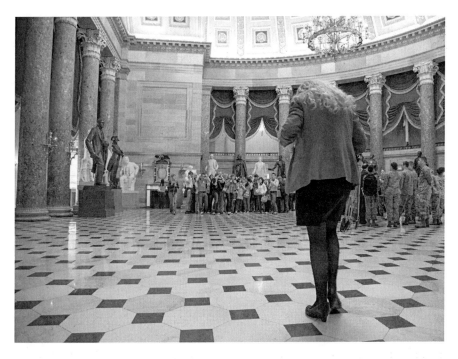

A Capitol tour guide showing a group of students how the whispering gallery works in the National Statuary collection. *Photo by Maria Helena Carey.*

made renovations necessary, particularly to the roof, there was an immediate outcry that this would remove this source of amusement.

The new roof—made of plaster and steel and replacing the plaster-and-lath ceiling—did in fact destroy some of the echoes, in spite of great attempts made to preserve the original shape. Others were modified, and new ones may have been created.

In 1936, a teacher from D.C.'s Roosevelt High School and a student finally conducted a scientific exploration of Statuary Hall's echoes. A *Popular Science* article on his discoveries writes of "the presiding officer of the House of Representatives" who "took advantage of the odd phenomenon to communicate privately with members seated thirty or forty feet away." The receiving end of the echo is said to be "almost directly above a brass plate that marks the spot where John Quincy Adams died in 1848." The article did not, however, actively accuse Adams of eavesdropping; that would have to wait for a few more years.

In 1963, the Government Printing Office published a pamphlet with the unwieldy title *Our Capitol: Factual Information Pertaining to Our Capitol and Places*

of Historic Interest in the National Capital. In it, the connection between the location of Adams's desk and the target of the echo is made for the first time. What is made as well is the inference that Adams used this knowledge to confound his opponents. It is from this pamphlet that the quote at the top of this section comes. Since then, it has become part of the lore of the Capitol, and it continues to be repeated today.

There is no reason to believe that Adams actually ever eavesdropped on anyone in this manner. Even had this echo survived intact through the various renovations, it would still have required the eavesdroppees to have been standing at one particular spot. Furthermore, it is quite possible that this exact echo did not exist before the 1902 renovation. And finally, there is no contemporary account of anything of this nature happening; in fact, the first descriptions of the echoes come well after the hall had been vacated by the House of Representatives and turned over to the Statuary collection.

Nonetheless, the echoes remain a fixed part of every tour of Statuary Hall to this day, and every Capitol tour guide briefly leaves his or her charges at the location of the Adams desk and whispers to them from a spot many feet away.

KEEPING THE FLAME ALIVE

Ben Butler, when a member of Congress, was sapping and mining one day in an almost forgotten catacomb under the dreary building known as the Capitol at Washington when he encountered a spectral-looking individual who seemed disposed to escape observation. "Who are you?" queried the investigating Congressman. "I am keeper of the General Washington crypt." "But General Washington was buried at Mount Vernon, twenty miles from here." "Nevertheless, yonder is his crypt." "Are you paid a salary?" "I have fifteen hundred dollars a year, and I succeeded my father in office." This sent the investigator to the records, who discovered that sixty-five years previously, a certain congress, expecting to entomb General Washington under the Capitol, had established a crypt and a keeper of it. Other Congresses forgot the subject, but the salary survived, while the "patriotism" of successive secretaries of the treasury forbade inquiry into the subject. Very soon afterward, upon relating his tale to the house—shouts of laughter drowning "patriotism"—General Butler passed his anti-sinecure bill.
—Daily Astorian *(Oregon) May 28, 1885*

Representative Benjamin Franklin
Butler. *Brady-Handy Photograph
Collection, Library of Congress.*

Benjamin Franklin Butler is one of those larger-than-life characters who shows up at important crossroads throughout the nineteenth century. A lawyer by trade, he began dabbling in politics before the Civil War and managed to have himself named a general following the outbreak of hostilities. After being involved in numerous battles, he returned to civilian life and was elected to the House of Representatives from his home state of Massachusetts. He soon made a name for himself as one of the managers for the impeachment trial of President Johnson in 1868.

The following year, Butler made a discovery that has kept his name—or at least this story—in people's memory ever since. How he came to make this discovery is told in two different ways: either he was spelunking through the basement of the Capitol or he was closely reading the year's budget. Either way, he came across evidence of an individual whose job was to keep alive the eternal flame burning above the tomb of George Washington—a tomb that had never been filled as intended. More importantly to Butler, however, was the fact that this factotum had been paid to watch the flame since the earliest days of the Capitol and in fact had inherited the job from his father before him.

Clearly, every year, the supposed guardians of the public purse had simply taken over the line item from the previous year's budget, and the keeper found himself the perfect sinecure: a job in which all he had to do was show up for a few hours a day, collecting for this a handsome paycheck.

Butler had the poor wretch fired immediately, saving the country literally hundreds of dollars.

However it is told, it is a great story, particularly for those who feel that the government's budget has gotten out of hand and that Congress is lavish and wasteful—and does not even know where all the money is going. It is a story that resonated not only in 1869 but also today. It is also a story that is almost completely without truth.

How did such a story come to be? The genesis was in an article published in the *New York Tribune* in 1869. In it, Butler indeed finds a line item in a budget that he cannot make heads or tails of, marked "Superintendent of the Crypt." When his fellow congressmen profess ignorance as to its meaning, he discovers—and fires—the superintendent, who has been receiving a paycheck for the past forty years. His entire job in this time had been to "sit near the Crypt daily, from 9 a.m. until 3 p.m., and see that only one gas burner was used." What is meant, exactly, by the last phrase is unclear; possibly, that the superintendent is to ensure that no more than one light burns, to keep the possibility of fire breaking out to a minimum. The original newspaper story thus follows one of the tellings of the tale fairly closely.

Unfortunately, the unnamed writer of the story seems to have done no real research in writing the story. Had he done so, he would have learned a few things—most importantly, that the line item for a watchman in the crypt had been added only a few months before Butler "discovered" it. Previously, the watchman had simply been part of the budget for the Capitol police. Secondly, far from being a sinecure with no real duties, the watchman was responsible for keeping order in the crypt, which was an important passageway at the time. The Capitol was used by many more people in those days, and keeping those who were simply there for recreation away from those working there was an important job. Finally, the job had not been around since the building of the Capitol but rather since the mid-1850s, coinciding with the replacement of the heating system in the Capitol, when the fires in the crypt that had previously warmed the congressmen were replaced with a more modern heating system.

It should also be noted that, as part of the impeachment trial of President Johnson, Butler prepared a list of all officers of the United States who served at the president's pleasure. Included on the list? A "watchman in the crypt."

The former location of the railing that kept people in the Capitol rotunda from falling down into the crypt and onto George Washington's purported eternal flame. *Photo by Maria Helena Carey.*

Had Butler looked at the papers turned over to him for the trial, he could have discovered this "sinecure" a whole year earlier.

In short, very little of the original story was true. Nonetheless, versions of this report were printed all across the country, along with a fair bit of outrage at this waste of taxpayer dollars. In the telling, the tale grew, acquiring various additions over the years, most often that the keeper of the crypt was responsible for the eternal flame that burned above what was to be Washington's tomb.

For instance, in July 1877, the *Atlantic Monthly* published a piece entitled "A Century of Congress," written by the man representing Ohio's Nineteenth District in Congress. Within it is a short paragraph with the following story:

> *In the crypt constructed under the dome of the Capitol, as the resting-place for the remains of Washington, a guard was stationed, and a light was kept burning for more than half a century. Indeed, the office of keeper of the crypt was not abolished until after the late war.*

The author, who would become the twentieth president of the United States less than three years later, was James A. Garfield. He had added (or,

more accurately, distorted) one fact from the original story in that he had made the "one gas burner" that was originally mentioned into a "light that was kept burning for more than half a century." This particular change is one that has made its way into almost all modern tellings. It is in essentially this final version of the tale that appeared in Dan Brown's novel *The Lost Symbol*:

> *"The hole in the floor* [of the Capitol Rotunda]*,"* Langdon told them, *"was eventually covered, but for a good while, those who visited the Rotunda could see straight down to the fire that burned below."*
> Sato turned. *"Fire? In the U.S. Capitol?"*
> *"More of a large torch, actually—an eternal flame that burned in the crypt directly beneath us. It was supposed to be visible through the hole in the floor, making this room a modern Temple of Vesta. This building even had its own vestal virgin—a federal employee called the Keeper of the Crypt—who successfully kept the flame burning for fifty years, until politics, religion, and smoke damage snuffed out the idea."*

Though it would be nice to think that a thorough debunking of the tale will ensure that it will no longer be repeated, this would be entirely contrary to previous experience. As long as people rail against the unmanageable size of government, this story will be told and retold—possibly with new details added—as a cautionary example.

THE WOMAN'S MOVEMENT

Within the walls of the United States Capitol Building there is a statue, The Portrait Monument, *which honors the women's suffrage movement. But what makes this statue really unique is the fact that it is not yet completed. Adelaide Johnson sculpted* The Portrait Monument *out of eight tons of marble. Johnson kept in mind that even though America had come a long way from the women's suffrage movement, many issues still remain regarding women's rights. Because of these issues, she left a piece of the rock uncarved for a future women's rights leader. My assumption is that when America elects its first "Madam President," this statue will be completed.*
—Conservatives4Palin, July 16, 2011

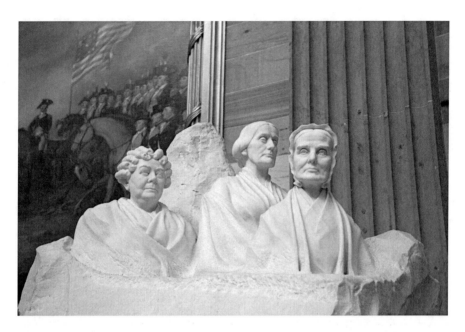

The Woman's Movement statue group in its current location in the Rotunda of the Capitol. *Photo by Maria Helena Carey.*

Along with the statues in the Capitol building that are part of the national statuary collection, there are also a number of statues that were given to or commissioned by Congress. The most famous of these is one known officially as *The Portrait Monument to Lucretia Mott, Elizabeth Cady Stanton and Susan B. Anthony*. The statue, also sometimes referred to as *The Woman's Movement* or pungently if less respectfully as *Three Women in a Bathtub*, consists of the busts of these three leaders of the woman's suffrage movement and was sculpted by Adelaide Johnson. The monument was presented to Congress by the National Woman's Party and unveiled in the Rotunda in 1921.

Woman's suffrage was a late arrival in the United States. Women were not given the right to vote in national elections until August 18, 1920, when Tennessee became the thirty-sixth state to ratify the Nineteenth Amendment, almost forty years after Susan B. Anthony and Elizabeth Cady Stanton had drafted it.

Adelaide Johnson, already well regarded as a sculptor, was commissioned by the National Woman's Party to create a monument to those who fought to give women the vote. For her monument, she chose three of the most important suffragists: the two drafters of the Nineteenth Amendment along

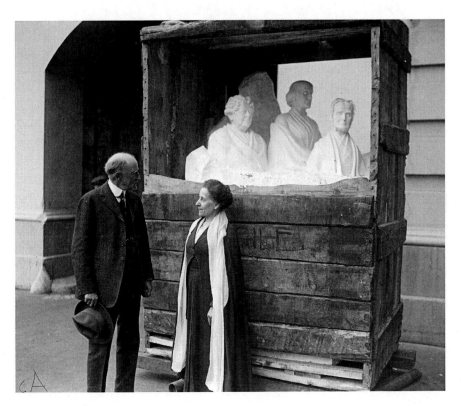

The Portrait Monument arrives at the Capitol along with Adelaide Johnson and an unknown male. *Harris & Ewing Collection, Library of Congress.*

with Lucretia Mott, who had been an early proponent of voting rights, as well as Stanton's mentor.

None of these three leaders had seen women's suffrage become the law of the land, but Johnson, who had been active as a sculptor for over forty years by this time, had done portrait busts of all three over the years. Beginning with a sixteen-thousand-pound block of Carrara marble, she sculpted three busts coming out of the rough stone. Behind the three is a bust-sized lump of unfinished marble, and it is this around which so many stories swirl.

To Johnson, the unfinished appearance referred solely to the unfinished work for women's rights. She saw herself as a "feminist, not merely a suffragist," and thought that simply having the vote was an important step along the road but by no means the final destination. A 1986 monograph on Johnson states that "the roughly cut mass of marble…may be interpreted as representing all the unidentified, unheralded persons who have, or will,

work for woman's rights—a kind of an unknown soldier of the woman's movement." No one has ever credibly shown that Johnson hoped that someone else would eventually "complete" her monument—in particular, to add a bust of the first female president.

On February 15, 1921, with an enormous amount of pomp, the new statue was unveiled in the Rotunda of the Capitol. With Jane Addams presiding, Speaker of the House Frederick H. Gillett there to receive the statue on behalf of Congress and young women representing women's groups from around the country in attendance, two women in the garb of Greek goddesses removed a veil covering the statue while an opera singer sang a popular hymn. The only complaints came from Senator James D. Phelan of California, who hoped the statue would soon be removed, as it was "bad art." Instead, it was Phelan who left a few weeks later, as he had lost his reelection campaign the previous year.

Sadly, the statue, like Senator Phelan, did not stay long in this prominent place. Instead, it soon found itself in "an obscure corner of the Capitol basement." The National Woman's Party was appalled, and it convinced the powers that be to move it to the center of the crypt, directly below the Rotunda—and right where George Washington was to have been buried. This raised the ire of the Capitol tour guides, who felt that it blocked the unobstructed view of the "longest corridor in the world." Thus, the following year, it was shifted again to one side of the crypt. All of these movements occurred within a year of its original unveiling, reflecting the enormous amount of controversy the statue had unleashed. However, after this peripatetic year, the statue remained at rest for over fifty years.

In 1995, a measure was approved by the Senate to move the statue back into the Rotunda. All was well until Newt Gingrich, Sue Myrick and other members of the House of Representatives objected. They refused to allow any public monies to be spent on the move, which meant that a hastily formed group named the Woman Suffrage Statue Campaign had to raise the money to return the statue to its original location.

Money raised, the statue was moved back into the Rotunda in 1997—though not before further controversy broke out as to whether or not the statue should be changed to add the bust of Sojourner Truth, the famous nineteenth-century African American suffragist. Although at the time, the decision was made not to change the statue, in 2004, over one-third of the Senate signed on to S. 2600, a bill that would have added Sojourner Truth to the monument. Sponsored by Hillary Clinton and co-sponsored by thirty-six fellow senators, this bill was referred to the Committee on Rules

and Administrations, where it died with the end of the 108th Congress. This remained the closest that it has ever come to actually being changed. One hopes that when the first female president is elected, there will not be a similarly misguided effort to add her bust to the monument.

Meanwhile, *The Portrait Monument* remains in its prominent spot in the Rotunda, visited by millions of tourists every year and surrounded by the portraits of the likes of George Washington, Abraham Lincoln, Thomas Jefferson and Martin Luther King Jr.

A STATUE FIT FOR A KING

King Kamehameha is an interesting statue. I'll just tell you the story behind it. He was the first king to unite all the Hawaiian Islands under a peaceable kingdom. And, of course, King Kamehameha was honored by the Hawaiian people by being placed in Statuary Hall. But when they first sent the statue over, they discovered that it wasn't wearing any clothing. Congress was very upset and sent the statue back and said, "Put some clothes on it." So Hawaii took it back, and they dressed it as you see here. But even then Congress wasn't happy because he wasn't that decently dressed— he's not really covered—and so they decided to put him back here as punishment. They stuck him back here in this corner where nobody would notice him.
—Hawaii Star, July 17, 2003

Six years after the creation of the National Statuary collection, the first statue, that of Revolutionary War hero Nathanael Greene, donated by Rhode Island, was placed in the old hall of the House of Representatives. Greene's statue, done by Henry Kirke Brown, set the tone for those that came after: a white male standing in heroic pose. For the next fifty years, this was the template that was followed, though eventually, both the subjects chosen and how they are portrayed has become more diverse.

One of the more impressive examples is the statue of King Kamehameha I, a copy of an 1880 statue by Thomas R. Gould, which was given by the State of Hawaii in 1969. Kamehameha was an obvious choice for a statue, as he had created the Kingdom of Hawai'i in 1810 after conquering the individual islands and thus making for a powerful country that was able to remain independent while other Pacific islands were being colonized.

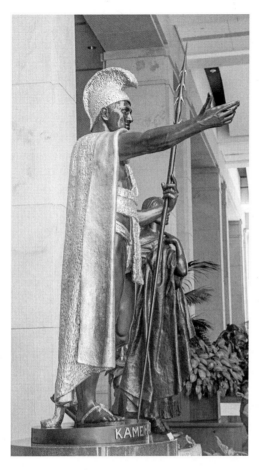

The statue of King Kamehameha I in the Capitol's visitors' center. *Photo by Maria Helena Carey.*

Even beyond the subject's obvious historical importance, the statue itself was striking. Kamehameha I is shown standing, with one hand outstretched, while wearing a cape and headdress and holding a spear. Even more eye-catching is that the clothing he is wearing is plated in gold, making it a bright spot among the otherwise muted shades of the other statues. The statue is also taller than its brethren in the Statuary Collection and thus also the heaviest.

It was due to its weight that Kamehameha was originally relegated to a far corner of the collection. Weight had been a serious issue for the former home of the House of Representatives. In 1933, the weight of the sixty-five statues given up to that point was beginning to concern David Lynn, the architect of the Capitol. No further statues could be added, and even those that were there were not well displayed, some being placed three deep to accommodate them all.

Congress thus passed another act, one allowing statues to be spread out inside the Capitol. Thirty-six years later, Hawaii joined the other states in sending statues to the Capitol. On April 15, 1969, the two (the other statue was of Father Damien) were unveiled in the Rotunda. Thereafter, Kamehameha was placed in the Hall of Columns, below the hall of the House of Representatives. Soon thereafter, however, he was moved into Statuary Hall, though into "a corner, behind some columns," as a 1971 article described it.

The location was chosen entirely based on the weight of Kamehameha, not how he was dressed. Nonetheless, over the years, various stories began

to arise about how the statue was banished into a corner. Tour guides and, especially, congressional staffers who had been asked to give tours for constituents were particularly fond of the tale, which did explain how such a remarkable statue should come to be in such an out-of-the-way place.

Matters came to a head in 2003 when a Hawaiian reporter videotaped a non-Hawaiian staffer talking about the statue and repeating the legend. The clip ran on Hawaiian television shortly thereafter and caused a furor in the state. In reaction, Hawaiian representatives Ed Case and Neil Abercrombie wrote a letter to the current architect of the Capitol, Alan Hantman, describing the broadcast and its misinformation, stating that this was not an unusual occurrence and asking him to reconsider the location of the statue and wondering whether the reason for its relegation to a dark corner was indeed "exclusively structural."

As it turned out, there was a ready-made solution to the problem. Three years before Case and Abercrombie wrote their letter, construction had begun on the Capitol's visitors' center, an underground expansion of the Capitol that included space for tourists to begin their tours of the building. The centerpiece of this was the Great Hall, which had desks for distributing tickets and space for visitors to wait for their tours and was also a perfect location for some of the Statuary Collection. Thus, under the north skylight that floods the hall with sun—one place where nobody can walk over him—stands the statue of Kamehameha I, no longer hidden in a corner.

Across the River

Washington, D.C., was originally quite a bit bigger than it is today, as both Alexandria and Arlington County were, from 1790 until 1847, part of the federal district. This land was given to the federal government by the Commonwealth of Virginia, and when it realized that none of it had

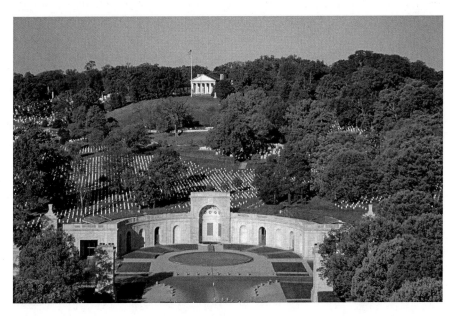

Aerial view of Arlington Cemetery. *Carol Highsmith Collection, Library of Congress.*

actually been used for purposes of government, nor was this use likely, it requested it back. Since that time, a number of important landmarks that belong, in principle, to D.C. have been built there—and numerous urban legends have grown up around them.

PENTAGON PLANS

I heard years ago that the Pentagon was originally going to be a hospital (mostly hallways and ramps for gurney's, etc).
—*commenter at WashingtonPost.com, June 13, 2007*

The Pentagon, headquarters for the United States Department of Defense, is an enormous building. It is the largest office building in the world, housing over thirty thousand employees in its 6.6 million square feet. Its 4 million square feet of office space was double that of the previous record holder, the Empire State Building. The building is almost one mile around its perimeter, and within are five concentric buildings, with the innermost ring still 350 feet to a side.

Even more remarkable is the fact that the whole thing was built in record time. Between the beginning of construction on September 11, 1941, and Secretary of War Henry Stimson's moving in, a few more days than fourteen months had passed—and the first employees had been there over six months already. Conceived with the near-certainty that the United States would soon enter the war that already spanned the globe, and built mainly after the attack on Pearl Harbor, the Pentagon had to be built to house enormous numbers of workers and built in a way that would not slow down the production of weapons needed on the front lines.

Certain concessions had to be made to accomplish this. For one, the building was only four stories high to obviate the need for a steel frame while still ensuring its structural integrity. For another, extensive use was made of ramps within the building that were big enough to accommodate trucks to move goods between floors instead of elevators, which were entirely eliminated—except for the private elevator that allowed the secretary of war and army chief of staff to get to their offices directly from the basement parking lot. These design changes saved thirty-eight thousand tons of steel, enough to build a whole battleship, as the public relations arm of the War Department liked to trumpet.

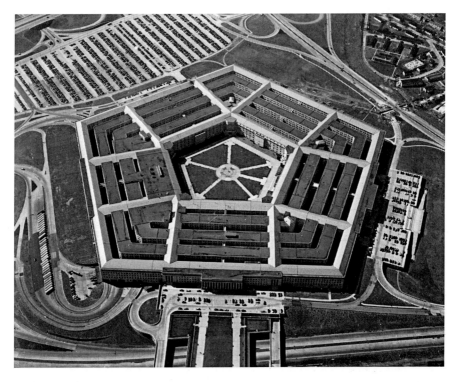

Aerial view of the Pentagon. *Theodor Horydczak Collection, Library of Congress.*

The ramps became the origin of the legend that the Pentagon was designed for a completely different purpose but was then used by the military with the United States' entry into World War II. Other features cited are its wide hallways and many bathrooms. The size of the hallways was simply due to the enormous number of people who would be working in the building, while the large number of bathrooms actually came about due to the segregation laws then in force in Virginia. Instead of two restrooms, to separate the sexes, four were built on each of the major hallways so that the races could be separated, as well. Due to President Franklin D. Roosevelt's signing of a law outlawing discrimination in government buildings, the signs indicating which was which were never installed, and private attempts to enforce segregation were quickly erased.

Even as the Pentagon was being built, there were some who looked beyond the current crises and imagined what might come of this gargantuan space once the war was over. It was unfathomable that so much space would be needed to house the military command once the fighting was over, unless it

indicated a desire by the United States to "police the world after the war is over," in the words of Representative August Andresen. Others sought to dampen these fears by suggesting that the building would be used to house an infantry regiment or to take in the country's records. President Roosevelt was particularly enamored of the latter suggestion. He hoped that the War Department would move back across the river after the war and that the new building would "be used as a records building for the government." Even General Brehon B. Somervell, head of the Army Service Forces and thus directly in charge of the building of the Pentagon, said that the new building would make a "dandy" archive, though he insisted that the country first deal with the current emergency before making any further decisions as to its use.

At the end of hostilities, in spite of the excellent service the building had rendered in assisting the U.S. Army to prosecute the war, the question of what to do with the massive building was reopened. Steve Vogel, in his masterful book *The Pentagon: A History*, writes:

> *There had been no shortage of suggestions, most of them sardonic, of what to do with the place. The Pentagon could shelter a second bonus army; the government could rent out the space to all the generals who wanted to write their wartime memoirs; six-day bicycle races could be staged in the building's outer ring.* Life *magazine reported, tongue in cheek, that the Pentagon might host peace talks after the war because it was "the only building in the world large enough to hold all the factions that will have a say-so on the treaty."*

Even more unlikely was the suggestion made by an army officer, a self-professed "paragraph trooper" (someone who had spent his service time pushing paper rather than fighting) who posited that the "building should be closed tight, its keys thrown away, and on top a large sign erected for all to see and read: 'WASHINGTON SLEPT HERE.'"

More serious people weighed in as well. Congressman Thomas D'Alesandro Jr. of Maryland revived the idea of turning the Pentagon into a hospital—the world's largest. President Truman saw it as the ideal location for the Veterans' Administration. Still others saw it more in terms of an enormous university.

Instead, on August 29, 1949, before any of these plans could be turned into reality, the Soviet Union exploded its first atomic bomb, and the Pentagon found itself at the center of the Cold War—and another urban legend.

The Ground Zero Café

In the middle of the Pentagon is an open pentagonal courtyard, and at the center of this mostly grassy area is a small shack, which—as other versions of this legend assert—the Soviets believed contained the entrance to an underground bunker containing the "most top-secret meeting room." In fact, again according to legend, they believed that "the entire Pentagon was a large fortress built around" it. Instead, as any visitor could attest, it was simply a mundane hot-dog stand, surrounded by picnic tables. The inner courtyard and its tables were very popular because "at lunchtime, hordes of miniskirted secretaries crossed their shapely legs at these tables." So naturally, most of the male employees followed along.
—*Jani Scandura,* Down in the Dumps, *2008*

A structure in the center of the Pentagon was a feature of the inner courtyard from almost the beginning, when the War Department set up a tent bought from a resort on Coney Island. Postwar pictures show nothing in the center, but a more permanent structure in the shape of a clapboard shack was placed there later. In the late 1980s, a more substantial five-sided building replaced the shack, which was itself replaced in 2006 with a building that looked as much as the older one as possible. (Since 1992, the Pentagon, and particularly the courtyard, has been a national historical landmark, and thus only minimal changes are allowed.)

Other versions of the rumor indicate that the Soviets never had fewer than two missiles pointed at this target, an example of the nuclear overkill that both sides of the Cold War engaged in.

The story makes for a wonderful image, that of clueless Soviet generals pointing part of their precious arsenal at such a humble target. Even more delicious is the moment when they are told of their misplaced priorities by their American counterparts, causing the embarrassed Soviets to change the targeting of those missiles.

Others refer to this hot-dog stand simply as "Ground Zero." A letter writer to the *New York Times* expressed it thus: "Think of what that means: the awesome nuclear power of the Soviet Union targeting a hot-dog stand. It somehow makes black holes pale by comparison."

As it turns out, this view of the role of the hot-dog stand is far more accurate than any purporting to portray the Soviets' beliefs about some super-secret bunker entrance. The fact of the matter is that the accuracy of Soviet ICBMs meant that anything aimed at the Pentagon would probably not hit it at all.

The hot-dog shack in the courtyard of the Pentagon. *Department of Defense.*

Take, for instance, the Soviet SS-18. This missile, codenamed Satan by NATO, was first deployed in 1967 and remains a mainstay of the Russian ICBM fleet today. It is thus not completely out of the question that it was one of these that targeted the Pentagon. The SS-18's accuracy is about 500 circular error probability (usually shortened by the military to CEP), which means that an SS-18 aimed at the center of the Pentagon would, with 50 percent probability, hit somewhere inside a circle five hundred meters in diameter around the actual target. This circle includes the three roads that ring the building, an area several times larger than the Pentagon itself. Thus, it would be reasonably unlikely that the Pentagon would be hit and exceedingly unlikely that the hot-dog stand itself would be hit by the missile.

However, when dealing with nuclear blasts, it is not just a question of the accuracy of the missile but also the size of the blast radius of its detonation that is crucial. The usual warhead of an SS-18 had an effective force of twenty megatons of TNT, creating a blast radius of two miles. This means that within one one-hundredth of a second of exploding, the warhead would create a fireball reaching out for two miles in every direction from the

impact site. Temperatures within this radius would rise to 20 million degrees Fahrenheit, and everything—the Pentagon, parking lots, roads, Arlington Cemetery, much of Arlington, a healthy portion of Washington and, of course, the Pentagon hot-dog stand—would be vaporized.

It seems that it is not just horseshoes and hand grenades where "close" is good enough.

BUILDING FOR SPITE

[The house at 325 Queen Street, Alexandria, Virginia,] *is called the Spite House by some because John Hollensbury, the owner of one of the adjacent houses, built it in 1830 to keep horse-drawn wagons and loiterers out of his alley.*
—New York Times, *February 29, 2008*

Building a house to keep your neighbors from using the land for other purposes—as a shortcut, dumping ground or for illicit purposes—is an old and honored tradition. Houses built for reasons other than to have more space are legion enough that they have been given a name: spite houses.

Many of these spite houses have become quite famous over the years. Frederick, Maryland, has the Tyler Spite House, which was built to keep the city from building a road through its lot. Similarly, in New York City, the Richardson Spite House stood at the corner of Eighty-second Street and Lexington Avenue for about thirty years at the turn of the nineteenth century. After a neighbor had offered what Joseph Richardson felt was an insultingly small sum for the land, reasoning that a lot only five feet deep would be worthless, Richardson proved him wrong by building an eight-unit apartment house that, for good measure, blocked the sun from his neighbor's house. In Boston, a young man returning from military service found that his brother had built his house on the lot they had inherited from their father in such a way as to apparently preclude any further building. The returnee then squeezed an oddly shaped house onto the remaining land, building it in such a way as to block sun and air from the previously built one.

Washington, D.C., is essentially free of spite houses, due to a law that ensured that every house must allow its neighbor to have adequate light. But you don't have to go far to find a house that, rumor has it, was built out of spite.

Across the Potomac from Washington is the Alexandria Spite House. It is certainly a remarkable place, being only seven feet wide, and essentially consists of two walls front and back plus a roof, all enclosing an old alleyway. It was built about 1830 by one John Hollensbury. Stories about it abound, whether that Hollensbury built it to keep the ladies of the night from plying their trade in the alley with the sailors who swarmed to Alexandria, to keep neighbors from passing through with their noisy carriages or simply to keep out loiterers.

The Spite House in Alexandria, Virginia. *Historic American Buildings Survey Collection, Library of Congress.*

The proponents of the alley theory point out that there are gouges in the wall still visible today, gouges made by the hubs of the wagon wheels that passed that way. However, Al Cox, Alexandria's code-enforcement architect, has his doubts about the story. In order to be a true spite house, Cox points out, it would have to have been built solely to keep others out. In other words, it is Hollensbury's intent that is key here. And this is where researching the story becomes quite difficult. Of the five "W" questions that should be answered in every good news story, the "who," "what," "when" and "where" are usually easy to determine from old records, while the "why" can remain indecipherable. Unfortunately, without a diary entry or a letter in which he declares the reason for having built the house to be to keep noisy neighbors out, there is no way to divine the builder's intentions. After all, it is perfectly possible that Hollensbury built the house on land he owned to house a part of his family.

Even without the designation, it makes for a colorful stop on a walking tour of Alexandria: a tiny, bright-blue house tucked between two much larger neighbors, and owners who are frequently interviewed about their domicile. Their main complaint? That being such a frequent stop on people's tours of Alexandria makes it "like living in a glass house."

Hollensbury's real intentions may remain unknown in perpetuity, but the Spite House will remain an Alexandria attraction for years to come.

Staging the Flag-Raising

The famous photograph of the raising of the American flag on Iwo Jima on February 23, 1945, turns out to be a "reconstruction" by an Associated Press photographer, Joe Rosenthal, of the morning flag-raising ceremony that followed the capture of Mount Suribachi, done later in the day and with a larger flag.
—Susan Sontag, Regarding the Pain of Others, *2004*

On the west bank of the Potomac, overlooking Washington, D.C., is one of the city's most iconic memorials: the Iwo Jima Memorial, correctly known as the Marine Corps War Memorial. Showing the struggle of five marines and a navy corpsman to raise a flag, it is based on what is probably the most famous photograph to come out of World War II: Joe Rosenthal's picture of the raising of a flag on the top of Mount Suribachi during the battle for Iwo Jima toward the end of the war. Taken on February 23, 1945, by February 25, it was on the front page of the *Washington Post*, as well as many other newspapers across the country. It was noted for its power from the moment it was developed and was used in war bond drives as well as U.S. Marine recruiting thereafter.

Along with its fame came a more sinister story: that the picture had been staged. While it is indisputably true that the flag in the famous picture was not the first to be raised on that mountain that day, the story began to circulate that Rosenthal had been involved in some shenanigans to create this iconic picture. There are two variants describing how the raising of the flag came to be staged:

1. The picture was staged; Rosenthal followed along a group of men sent to replace the original flag with a larger one and then had them pose in the form that has become so famous.

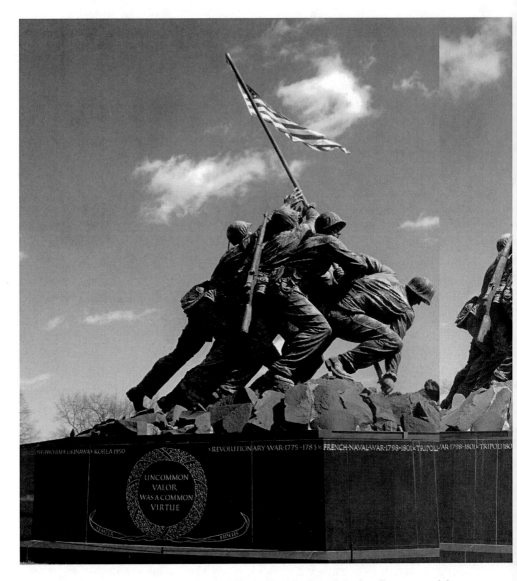

Although not a legend, this interesting optical illusion has the flag of the Iwo Jima memorial apparently rising as the viewer goes around it. The illusion can be seen in the above triptych, where each of the three pictures was taken from a slightly different angle. *Pictures by the author.*

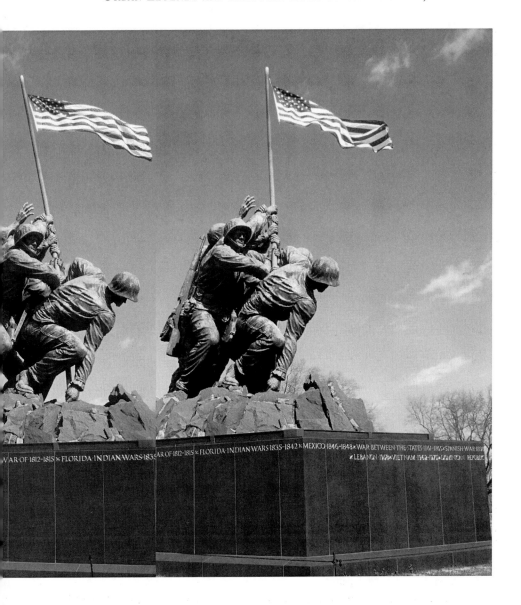

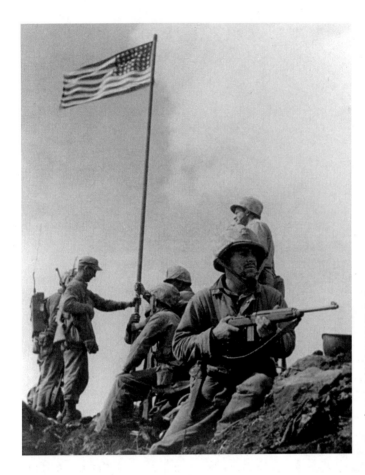

Leatherneck Magazine photographer Staff Sergeant Louis Lowery's picture of the first flag raised on the top of Mount Suribachi, Iwo Jima, on February 23, 1945. *Naval History and Heritage Command.*

2. The whole flag-raising was staged. This is the story told in the introduction to this section. The argument is that the picture of the first flag-raising was insufficiently photogenic, so Rosenthal recruited six men to repeat it.

There is, however, no real argument as to what happened among those who were actually there.

At 10:20 a.m. on February 23, 1945, with the battle for Iwo Jima now raging for four days, the marines had managed to send a patrol to the top of Mount Suribachi, the highest point on the island, without running into Japanese resistance. Though the battle was far from over, this meant that the U.S. forces now held the southern end of the island and could thus work their way north to capture the rest. It would take another month's fighting before the battle was over.

To secure the mountain, a platoon led by First Lieutenant Harold Schrier was sent by Battalion Commander Colonel Chandler Johnson, who also gave them a flag to raise at the top if they arrived. Their ascent and the planting of the flag was documented by Staff Sergeant Louis Lowery of *Leatherneck Magazine*, who coached the raising of the flag and even asked them to hold the pose while he reloaded his camera.

The raising of the flag encouraged marines on the island and on the ships surrounding it. The cheer that went up caused Japanese defenders still hidden in caves of the mountain to show themselves, touching off a brief firefight, during which Lowery's camera broke—though the film was saved.

Down below, Secretary of the Navy James Forrestal came ashore to see for himself how the battle was going. He mentioned that he would like to have the flag on Mount Suribachi as a souvenir, a request that angered Colonel Johnson, who felt that the flag belonged to his battalion. Johnson thus commanded another squad to retrieve the original flag and replace it with a larger one, as well as to run a telephone wire to the top.

Once the larger flag had been procured, the five men were sent up the mountain. As they were collecting the pipe on which to raise the flag, Joe Rosenthal, an AP photographer who was looking to take pictures from the top of the mountain, arrived there as well. He had originally hoped to take pictures of the first raising but had been too late. Fortunately, he had run into Lowery, now on his way down, who had assured Rosenthal and two others that the view from the top was worth taking pictures of.

Rosenthal crossed over to where six men were preparing the flag. He gathered up a few stones so that he would have a better vantage point. The marines, now with an additional navy corpsman who had been there for the first raising, were quicker than he, however, and as they began raising the flag, Rosenthal grabbed his camera and took a picture from his hip. He had no idea what he had caught on film and, in fact, would not see the image for quite some time. Rosenthal then had the men strike a pose for his camera to commemorate the moment. All of them then descended from the mountain and returned to their usual duties. Three of the marines involved in the raising never made it off the island alive.

The film was sent to Guam for processing. The first person to see it was a technician there. He passed it on to an AP photo editor, who had it sent back to New York City immediately. The photo was thus distributed by the Associated Press less than eighteen hours after being taken. In short order, it began its march onto the front pages of newspapers across the country and into the collective consciousness of people everywhere.

Thus, while the image captured by Rosenthal did not depict the first raising of a U.S. flag over Iwo Jima, the picture itself was entirely unstaged. Unfortunately, when Rosenthal was asked about the images later, he assumed he was being asked about the picture he had taken of the soldiers after the raising, which he had, indeed, staged. He freely admitted to this, and from there, the idea that he had been responsible for setting the scene of the iconic picture was printed far and wide. Much later, when asked about the whole situation, Rosenthal pointed out that he would have destroyed the picture had he set about stage-managing it, probably by reducing the number of men involved and generally breaking up the flow and shape that gives the picture its power.

THE HAND OF GOD

Count the hands on the [Iwo Jima] *statue. You'll be able to count an extra one—thus called the Hand of God.*
—commenter at TripAdvisor.com

The publication of Joe Rosenthal's picture began a long series of reproductions and reuses. Right off the bat, President Roosevelt recognized its value and had it used for the seventh, last and most successful war bond drive. Within the year, the post office had issued a stamp using the image, and Rosenthal won the 1945 Pulitzer Prize for Photography. The most important reproduction was, of course, Felix de Weldon's statue, which he began working on the day the picture was taken.

De Weldon was actually in the room as the picture came over the wire, and he—like the photo editor on the other side of the world—immediately recognized its power. De Weldon was employed by the U.S. Navy as a painter and was working on a painting of the Battle of the Coral Sea but asked for and received permission to make a statue of the raising of the flag instead. In short order, de Weldon had finished a small wax version of the statue. While Congress was interested in the statue, there was no money for it, so it was left to de Weldon to cast a version in stone. Three months later, this was completed and put up along Constitution Avenue in Washington. For the next two years, it stood across the street from the enormous Navy Department building before being removed in order to

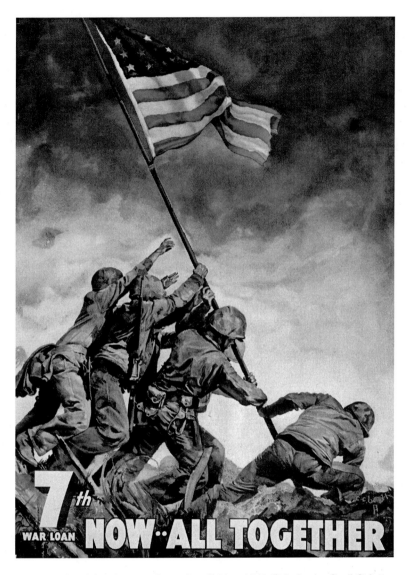

A poster advertising the seventh war bond drive, 1945. Painting by Cecil Calvert Beall, based on Joe Rosenthal's picture. *Library of Congress.*

make room for an expansion of the Pan American Union Building, which houses the Organization of American States.

Although now gone, the statue was far from forgotten, particularly by the marines who had fought at Iwo Jima. When it came time to put up a memorial to commemorate the marines who had fought in the nation's wars,

Rosenthal's image and de Weldon's statue thereof immediately came to mind. In 1951, de Weldon was put in charge of crafting a truly gargantuan version of his original statue. For the next three years, de Weldon labored at this task, and on November 10, 1954, the statue was unveiled.

At some point—and it is impossible to determine when this was—a rumor began to circulate that de Weldon had added an extra hand on the flagpole being raised. The thirteenth hand, it was said, was the "hand of God." Visitors since then have been encouraged to check this and have carefully counted their way around and indeed counted up to thirteen.

However, this is simply due to the difficulty of tracking which hands have been counted already and which have not—plus the power of suggestion. In 1999, a retired CIA officer and former marine named Tom Miller saw a group of tourists attempting to count the hands at the memorial. Miller had been on Iwo Jima and had witnessed the flag flying on the top of Mount Suribachi. He became intrigued by the story and did some research, including talking to de Weldon himself, figuring he would write a single-page handout to debunk the story.

As it turned out, Miller's handout turned into a twenty-page booklet, *The Iwo Jima Memorial and the Myth of the 13th Hand*, which was sold for many years at the gift shop at Arlington Cemetery and other places. Along with the thirteen-hands story, Miller also explains that the stones around the base of the statue are from Sweden, not Iwo Jima, another falsehood he had apparently heard. He mainly focuses on the hands and feet of the men hoisting the flag, providing exact descriptions of where to best see the individual hands. Furthermore, he makes the important point that only nine hands are actually on the flagpole; one man has released his grip, while a second has one hand on another's wrist.

Miller, however, did not relate the final word on the subject in his pamphlet. Instead, he mentioned them to a *Washington Post* reporter in 2005. According to Miller, de Weldon's response when questioned about the number of hands was to throw up his hands and say, "Thirteen hands—who needed thirteen hands? Twelve were enough."

Bibliography

INTRODUCTION

Abrams v. United States. 250 U.S. 616 (1919).

Chan, Terry, and Peter van der Linden. "alt.folklore.urban Frequently Asked Questions." www.faqs.org/faqs/folklore-faq/part1/.

Heath, Chip, Chris Bell and Emily Sternberg. "Emotional Selection in Memes: The Case of Urban Legends." *Journal of Personality and Social Psychology* 81, no. 6 (2001): 1028–41.

Schneier, Bruce. "Why FBI and CIA Didn't Connect the Dots." CNN.com, May 2, 2013.

Twain, Mark. *The Prince and the Pauper.* Boston: Osgood, 1882.

BUILDING THE NEW CAPITAL

No Dust, No Rocks

Arnebeck, Bob. "Was Washington Built on a Swamp?" http://bobarnebeck. com/swamp.html.

Berg, Scott W. "The Beginning of the Road." *Washington Post Magazine*, August 31, 2008.

Gates, Robert. Speech at the American Legion, Milwaukee, August 31, 2010.

Hutchins, Stilson, and Joseph West Moore. *The National Capital, Past and Present*. Washington, D.C.: Post Publishing, 1885.

Kelly, John. "Washington Built on a Swamp? Think Again." *Washington Post*, April 1, 2012.

Mandel, Susan. "The Lincoln Conspirator." *Washington Post*, February 3, 2008.

The Old Stone House

De Ferrari, John. *Lost Washington, D.C.* Charleston, SC: The History Press, 2011.

Gahn, Bessie Wilmarth. "George Washington's Headquarters." In *Georgetown and Colonial Days: Rock Creek to the Falls*. Washington, D.C.: Westland, 1940.

———. "Georgetown's Historic Taverns." *Washington Post*, December 15, 1940.

National Park Service. "The Old Stone House: Frequently Asked Questions." http://www.nps.gov/olst/faqs.htm.

"A Fine House in the Woods"

Clark, Allen C. *Greenleaf and Law in the Federal City.* Washington, D.C.: Roberts, 1901.

———. "William Mayne Duncanson." In *Records of the Columbia Historical Society* 14. Baltimore, MD: Waverly, 1911.

Fitzpatrick, John C., ed. *The Writings of George Washington from the Original Manuscript Sources, 1745–1799.* Washington, D.C.: United States Government Printing Office, 1944.

Jones, Dorothea. *Washington Is Wonderful.* Washington, D.C.: Harper & Brothers, 1956.

National Register of Historic Places. Friendship House. Washington, D.C.

Washington Post. "600 Watch Friendship House Take Over Historic Residence." November 29, 1937.

J Street

Frommer, Arthur, and Rena Bulkin. *Washington, D.C.: From $50 a Day.* New York: MacMillan, 1996.

Hunter, Marjorie. "A Street, Albeit Unofficial, Called J." *New York Times,* November 29, 1985.

Levey, Bob. "The Answer Man Takes on Three Smaller Issues." *Washington Post,* September 20, 1982.

Pardon, William. *A New General English Dictionary.* London: Toplis and Bunney, 1781.

The East Capitol Street Slave Market

Abdy, Edward S. *Journal of a Residence and Tour in the United States*. London: John Murray, 1835.

Council of the District of Columbia. *Laws of the Corporation of the City of Washington Passed by the 36ᵗʰ Council*. Washington, D.C.: Gideon, 1839.

———. *Laws of the Corporation of the City of Washington to the End of the Thirtieth Council, June 1833*. Washington, D.C.: De Krafft, 1833.

Gary, Ralph S. *Following in Lincoln's Footsteps: A Complete Annotated Reference to Hundreds of Historical Sites Visited by Abraham Lincoln*. New York: Basic, 2002.

Holland, Jesse. *Black Men Built the Capitol*. Guilford, CT: Globe Pequot, 2007.

Lincoln, Abraham. *Abraham Lincoln: His Speeches and Writings*. Cambridge, MA: Da Capo, 2001.

Northup, Solomon. *Twelve Years a Slave*. New York: Miller, Orton & Mulligan, 1855.

United States Congressional House. *Journal of the House of Representatives of the United States, Being the First Session of the Thirtieth Congress*. Washington, D.C.: Wendell and Benthuysen, 1848.

MONUMENTS AND MEMORIALS

High-Water Marks

L'Enfant, Peter. "Plan of the City Intended for the Permanent Seat of the Government of t[he] United States." 1791.

Penn Quarter Living. "Wayback III: Washington Monument Back in the Day." http://pqliving.com/wayback-iii-washington-monument/.

Torres, Louis. *To the Immortal Name and Memory of George Washington.* Washington, D.C.: U.S. Government Printing Office, 1984.

Washington Post. "Washington Monument." December 7, 1884.

Women and Children Last

Rash, Bryson B. *Footnote Washington: Tracking the Engaging, Humorous, and Surprising Bypaths of Capital History.* McLean, VA: EPM Publications, 1983.

St. Paul Daily Globe. "The Washington Monument." July 9, 1883.

Washington Evening Star. "The Elevator Man: His Experiences in Taking People to the Top of the Monument." September 19, 1885.

Washington Post. "The Elevator in the Monument." July 20, 1880.

———. "Making the First Trip." October 10, 1888.

———. "Up Nine Hundred Steps." August 22, 1886.

Looking Back on Lincoln

Brown, Joe, Elise Hartman Ford and Theodore Fischer. *Travel & Leisure: Washington, D.C.* New York: John Wiley & Sons Inc, 1997.

(Decatur, IL) *Herald & Review.* "Living with Lincoln." June 16, 1991.

U.S. Census Bureau. Twelfth Census of the United States, New York State, New York County, ED 985 sheet 6.

Washington Post. "Fight on Lee Statue." February 5, 1903.

Wills, Garry. *Lincoln at Gettysburg.* New York: Simon & Schuster, 1992.

Spelling the President

Chesterwood.org. "Frequently Asked Questions." http://chesterwood.org/faqs/.

Cresson, Margaret French. *Journey into Fame: The Life of Daniel Chester French.* Cambridge, MA: Harvard University Press, 1947.

de K, M.C. "A New Lincoln Statue and a Lincoln Story." *New Outlook,* September 29, 1920: 186.

Evelyn, Douglas E., and Paul Dickson. *On This Spot: Pinpointing the Past in Washington, D.C.* Washington, D.C.: Farragut, 1992.

National Park Service. "Lincoln Memorial Myths." http://www.nps.gov/linc/historyculture/lincoln-memorial-myths.htm.

Schein, Jerome D. *Language in Motion: Exploring the Nature of Sign.* Washington, D.C.: Gallaudet University Press, 1995.

Loose Cannons

New York Times. "Bullets Chip Lincoln Memorial." September 4, 1942.

———. "How L'Enfant Showed Dislike for Jay." July 15, 1985.

Rash, Bryson B. *Footnote Washington: Tracking the Engaging, Humorous, and Surprising Bypaths of Capital History.* McLean, VA: EPM Publications, 1983.

Washington Post. "House Told Ring of Big Guns Guards Capital from Raids." February 27, 1943.

———. "Lincoln Shrine Hit by Accidental Machinegun Fire." September 4, 1942.

The Hoof Code

Blattner, Don. *Amazing Facts About Mammals*. Greensboro, NC: Carson-Dellosa, 2006.

DCMemorials.com. "Equestrian Statues—Detail." http://www.dcmemorials.com/equestrian2.htm.

From the Fields of Gettysburg. "Gettysburg Monument Series—The Horse Hoof Question: An Enduring Myth." http://npsgnmp.wordpress.com/2012/07/20/gettysburg-monument-series-the-horse-hoof-question-an-enduring-myth/.

Kelly, John. "Answer Man Finds the Sculptor Who Broke the Mold." *Washington Post*, January 11, 2009.

vos Savant, Marilyn. "Ask Marilyn." *Parade*, July 15, 2001.

PRESIDENTIAL LEGENDS

Whitewashing the White House

Adams, Henry, ed. *Documents Relating to New-England Federalism, 1800–1815*. Boston: Little, Brown and Co., 1905.

Lesher, Will. "Little Known Facts About the Capital." *Washington Post*, February 13, 1921, 47.

Peck, Garrett. *The Smithsonian Castle and the Seneca Quarry*. Charleston, SC: The History Press, 2013.

White House Historical Association. "Why Is the White House White?" http://www.whitehousehistory.org/whha_history/history_faqs-01.html.

The Curse of Tecumseh

Allen, Richard Hinckley. *Star Names: Their Lore and Meanings*. New York: G.E. Stechert, 1899.

Clark, William A. "Dallas, Nov. 22—Two Chances for Tragedy." *Palm Beach Post*, November 22, 1972.

Holway, John. "Counting Their Stars." *Washington Post*, September 16, 1978.

Jones, George. *Tecumseh and the Prophet of the West*. London: Longman, Brown, Green & Longmans, 1844.

Martin, Joel, and William J. Birnes. *The Haunting of the Presidents: A Paranormal History of the U.S. Presidency*. New York: Signet, 2003.

New York Times. "Mr. Coolidge Breaks His Silence." August 3, 1927.

Ripley, Robert L. *Ripley's Believe It or Not!* New York: Simon & Schuster, 1934.

Schlesinger, Arthur. *Journals: 1952–2000*. New York: Penguin, 2007.

Shearer, Lloyd. "Curse or Coincidence?" *Parade*, September 28, 1980.

"Get Down, You Fool!"

Burlingame, Michael, and John Ettlinger, eds. *Inside Lincoln's White House: The Complete Civil War Diary of John Hay*. Carbondale: Southern Illinois University, 1999.

Cannon, James C. "Record of Service of Company K, 150th O.V.I., 1864." N.p.: 1903.

Cox, William V. "The Defenses of Washington: General Early's Advance on the Capital and the Battle of Fort Stevens, July 11 and 12, 1864." Records of the Columbia Historical Society. Washington, D.C.: Columbia Historical Society, 1900.

Cramer, John H. *Lincoln Under Enemy Fire*. Baton Rouge: Louisiana State University, 1948.

Hicks, Frederick C. "Lincoln, Wright, and Homes at Fort Stevens." *Journal of the Illinois State Historical Society* (March 1946): 323.

Welles, Gideon. *Diary of Gideon Welles Volume II*. New York: Houghton Mifflin, 1911.

Woollcott, Alexander. "Get Down, You Fool!" *Atlantic Monthly*, February, 1938.

Stuck in the White House

Bagni, Gwen, and Paul Dubov. "Backstairs at the White House: President Taft Loved Rich Food, Fought Vain Battle Against Waist." *Milwaukee Journal*, January 22, 1979.

Bishop, Jim. "Reporter." *Reading (PA) Eagle*, July 12, 1968.

Chace, James. *1912*. New York: Simon & Schuster, 2004.

New York Tribune. "Taft's Displacement Floods Bathtub in Hotel Cape May." June 19, 1915.

Poore, C.O. "Ten Presidents off Parade: 'Ike' Hoover's Extremely Readable White House Recollections." *New York Times*, September 23, 1943.

Warren (MN) Sheaf. "Gigantic Bathtub for Taft: Battleship Will Have Special Plan for Guest's Plunge." February 18, 1909.

Flying the Flag

(Withrow, WA) *Banner*. "The President's Flag." March 9, 1911.

Harris, Louise. *Old Glory—Long May She Wave*. Providence, RI: Brown University, 1981.

Washington Post. "White House Flag Comes Down 'Til Repair Is Complete." December 24, 1949.

Zibart, Eve. *The Unofficial Guide to Washington, D.C.* New York: Wiley, 2011.

THE SPORTING LIFE

Stretching Taft

Baltimore Sun. "Taft Sees Ball Game." April 20, 1909.

Sporting Life. "McKinley on Ball." April 24, 1897.

Sudyk, Bob. "Pro-Files: How the Seventh-Inning-Stretch Started." *Washington (PA) Observer*, August 25, 1964.

(Dubuque, IA) *Telegraph-Herald.* "Busy Day for President." May 30, 1909.

Washington Evening Star. "Season Well Opened." April 23, 1897.

Washington Herald. "Down Rivals." April 15, 1910.

Washington Post. "Good Work Goes On." July 26, 1887.

———. "'The Lucky Seventh.'" June 25, 1905.

Washington Times. "'Play Ball!' Is Slogan; President on Slab." April 14, 1910.

A Cuban Senator

Addie, Bob. "Bob Addie's Column." *Washington Post*, March 8, 1959.

Baltimore Sun. "Castro Invited to Pitch in D.C." April 21, 1959.

(Ottawa QC) Citizen. "History Altered by Baseball." October 26, 1961.

Echevarria, Roberto Gonzalez. *The Pride of Havana: A History of Cuban Baseball.* New York: Oxford University Press, 1999.

Gosse, Van. *Where the Boys Are: Cuba, Cold War America, and the Making of a New Left.* New York: Verso, 1993.

Krich, John. "Journey to the End of Baseball." *Mother Jones* (August–September 1987): 34.

Martin, Whitney. "Sports Trail." *Charleston Gazette*, March 19, 1940.

Reading the Football Results

Hofheimer, Bill. "'Redskins Rule': MNF's Hirdt on Intersection of Football and Politics." ESPN.com, October 30, 2012.

Lemke, Tim. "Redskins Rule Ideal for 'Monday Night.'" *Washington Times*, November 3, 2008.

Munro, Randall. "Electoral Precedent." xkcd, http://xkcd.com/1122/.

Ulick, Jake. "Hail to the Dow?" CNNMoney.com, November 1, 2000.

ALL AROUND THE DISTRICT

The Homesick Wife

(Philadelphia, PA) *Evening Telegraph.* "Election of Directors." May 1, 1867.

Jacobson, Stuart E., and Jill Spalding. *Only the Best: A Celebration of Gift Giving in America.* New York: Harry N. Abrams, 1985.

National Republican. "Congressional Reports." June 23, 1866.

Washington Post. "Buying a Million Feet of Land." September 15, 1889.

Williams, Paul K. *Images of America: Capitol Hill.* Charleston, SC: Arcadia Publishing, 2004.

The "Scaly Serpent of the Lobby"

Briggs, Emily Edson. "The Dragons of the Lobby: Messrs. Gould, Huntingdon, and Dillon and Their Cohorts, Washington, February, 1869," from *The Olivia Letters.* New York and Washington, D.C.: Neale, 1906.

Eskew, Garnett Laidlaw. *Willard's of Washington: The Epic of a Capital Caravansary.* New York: Coward-McCann, 1954.

Harper's New Monthly Magazine. "The M.C.'s Christmas Dream and the Lobby Member's Happy New-Year." December 1860, 52.

New York Daily Tribune. "Board of Aldermen." October 14, 1856.

Simon, John Y., ed. *The Papers of Ulysses S. Grant.* Carbondale: Southern Illinois University Press, 1967–2009.

USA Today. "10 Great Places to Hail Presidential Peculiarities." February 14, 2006.

Washington Critic. "The City." November 10, 1869.

Leading the "Sad Little Parade"

Detwiler, Mrs. "The City of Silence." http://www.congressionalcemetery.org/city-silence.

Kelly, John. "In Search of a Dubious Distinction: D.C.'s First Auto Fatality." *Washington Post,* February 5, 2013.

———. "Washington's First Recorded Traffic Fatality." *Washington Post*, February 7, 2013.

Mooney, Elizabeth C. "Monuments to Imagination as Well as to the Dead." *Baltimore Sun*, April 1, 1979.

Nelson, W. Dale. "Capitol Comment: Congressional Cemetery." (Nevada, MO) *Daily Mail*, August 31, 1982.

Washington Post. "Crushed Under Auto Car." September 23, 1904.

———. "Death Due to Accident." September 25, 1904.

———. "Sues Auto Company." November 24, 1904.

The Cabbage Memo

(Beaver and Rochester, PA) *Daily Times*. "Cabbage Seed Prices Deflated." August 20, 1943.

Fine, Gary Alan, and Barry O'Neill. "Policy Legends and Folklists: Traditional Beliefs in the Public Sphere." *Journal of American Folklore* 123, no. 488 (Spring 2010): 150–78.

Hall, Max. "The Great Cabbage Hoax: A Case Study." *Journal of Personality and Social Psychology* 2, no. 4 (October 1965): 563–69.

Ryan, Frederick J. *Ronald Reagan: The Great Communicator*. New York: Harper Perennial, 2001.

A Metro Stop for Georgetown

Blond, Becca, and Aaron Anderson. *Washington, D.C.* Melbourne, Australia: Lonely Planet, 2007.

Gorney, Cynthia. "Neighbors' Unity Wins Fight Against Metro Station Location." *Washington Post,* June 12, 1977.

Levey, Bob. "Georgetown Happy with Metro's Absence." *Washington Post,* June 30, 1977.

Schrag, Zachary M. *The Great Society Subway: A History of the Washington Metro.* Baltimore, MD: Johns Hopkins University Press, 2006.

CAPITOL TALES

Eavesdropping in the House

(Lincoln, NE) *Commoner.* "Save the Echoes." May 31, 1901.

Frazier, Emery L. *Our Capitol: Factual Information Pertaining to Our Capitol and Places of Historic Interest in the National Capital.* Washington, D.C.: U.S. Government Printing Office, 1963.

"Tests Explain Mystery of 'Whispering Galleries.'" *Popular Science Monthly* 129, no. 4 (October 1935): 23.

Trollope, Anthony. *North America.* Philadelphia: Lippincott, 1863.

Vale, Henry A. *Legislation Creating the National Statuary Hall in the Capitol.* Washington, D.C.: U.S. Government Printing Office, 1916.

Washington Post. "Capitol Chat." January 7, 1902.

———. "The Capitol's Wonders." May 14, 1878.

Keeping the Flame Alive

Brown, Dan. *The Lost Symbol*. New York: Doubleday, 2009.

(Astoria, OR) *Daily Astorian*. Untitled. May 28, 1884.

Garfield, James A. "A Century of Congress." *The Atlantic Monthly* 40 (1877): 49.

New York Tribune. "Washington: Discovery of a Remarkable Crypt." January 28, 1869.

United States Senate. *Proceedings in the Trial of Andrew Johnson, President of the United States, Before the United States Senate on Articles of Impeachment*. Washington, D.C.: F&J Rives and G.A. Bailey, 1868.

United States. Cong. House. Statements 40th Cong., 2nd Sess. H. Misc. Doc. 168. 1868.

The Woman's Movement

Brooke, James. "3 Suffragists (in Marble) to Move Up in the Capitol." *New York Times*, September 27, 1996.

Burton, Shirley J. *Adelaide Johnson: To Make Immortal Their Adventurous Will*. Macomb: Western Illinois University, 1986.

McAulay, Madeleine. "Youth Perspective: Famous Women's Suffrage Statue Needs President Palin." http://conservatives4palin.com/2011/07/youth-perspective-famous-womens-suffrage-statue-needs-president-palin.html.

New York Times. "Suffrage Statue Moves." February 14, 1922.

United States Congressional Senate. "S. 2600—A Bill to Direct the Architect of the Capitol to Enter into a Contract to Revise the Statue Commemorating Women's Suffrage Located in the Rotunda of the

United States Capitol to Include a Likeness of Sojourner Truth." 108th Congress, June 24, 2004.

Washington Herald. "Ask Choice Site for Group." April 3, 1921.

———. "Congress Gets Marble Busts of Feminists." February 16, 1921.

Washington Post. "Suffrage Statue Moved." September 24, 1921.

A Statue Fit for a King

Ford, Elise. "Dome Is Where the Art Is." *Washington Post*, February 18, 1994.

Hawaii Star. "Reps Urge Greater Respect for Kamehameha Statue." July 17, 2003.

Ruane, Michael E. "A Veritable 'Who's That?' of U.S. History; Statuary at New Capitol Center an Eclectic Bunch." *Washington Post*, October 1, 2008.

Smyth, Jeannette. "Barefoot on a Lark." *Washington Post*, June 12, 1971.

ACROSS THE RIVER

Pentagon Plans

Kluttz, Jerry. "The Federal Diary: Postwar Dispensation for Pentagon Building." *Washington Post*, October 11, 1943.

Lauterbach, Richard E. "The Pentagon Puzzle." *Life*, May 24, 1943:11.

Vogel, Steve. "Books: 'The Pentagon: A History.'" (Transcript of online discussion.) *Washington Post*, June 13, 2007. http://www.washingtonpost.com/wp-dyn/content/discussion/2007/06/07/DI2007060701129.html.

———. *The Pentagon: A History*. New York: Random House, 2007.

Washington Post. "Army Will Not Confirm Pentagon Hospital Plan." January 7, 1943.

The Ground Zero Café

Scandura, Jani. *Down in the Dumps*. Durham, NC: Duke University Press, 2008.

Shook, Mark L. "Pity the Pentagon's Hot-Dog Stand." *New York Times*, March 16, 1983.

Smith, Steven Donald. "Pentagon Hot Dog Stand, Cold War Legend, to Be Torn Down." Defense.gov, September 20, 2006.

Vogel, Steve. *The Pentagon: A History*. New York: Random House, 2007.

Woolsey, Robert. *No Fighting in the War Room: Memoirs of a Spook*. Bloomington, IN: iUniverse, 2000.

Building for Spite

Bailey, Steve. "A Tiny, Beloved Home That Was Built for Spite." *New York Times*, February 29, 2008.

Cavileer, Sharon. *Virginia Curiosities*. Guilford, CT: Morris, 2006.

Cronin, Jim. "Living Sideways." *Boston Globe*, February 13, 2005.

Herron, Paul M. "Not Enough Room to Swing a Cat." *Washington Post*, January 6, 1952.

Kelly, John. "Answer Man: In Search of Houses That Spite Built." *Washington Post*, March 26, 2006.

Koletar, Joseph W. "Letters." *Old-House Journal* (November 1993): 8.

Staging the Flag-Raising

Bradley, James. *Flags of Our Fathers*. New York: Bantam, 2000.

Leary, Kevin. "Joe Rosenthal: 1911–2006." *San Francisco Chronicle*, August 21, 2006.

Sontag, Susan. *Regarding the Pain of Others*. New York: Picador, 2004.

Washington Post. "Old Glory Blows Over a Japanese Stronghold." February 25, 1945.

The Hand of God

Kelly, John. "One Marine's Moment." *Washington Post*, February 23, 2005.

Miller, Thomas W. "The Iwo Jima Memorial and the Myth of the 13th Hand." Arlington, VA: Self-published, 1999.

Price, Virginia B. "By Design: Iwo Jima and the U.S. Marine Corps War Memorial." *The Arlington Historical Magazine* 14, no. 1 (2009): 35–45.

TripAdvisor.com. "U.S. Marine Corps War Memorial: Traveler Reviews." http://www.tripadvisor.com/Attraction_Review-g30242-d103272-Reviews-U_S_Marine_Corps_War_Memorial-Arlington_Virginia.html.

About the Author

Robert Pohl, author of *Wicked Capitol Hill*, is a stay-at-home dad and tour guide. He writes a regular column for both the *Hill Rag* and *The Hill Is Home*. When he isn't spending time with his family, Pohl volunteers at his local library and his son's school. He lives on Capitol Hill with his wife and son and the family's two cats.

Photo by Ian Herzog-Pohl.

Visit us at
www.historypress.net
..
This title is also available as an e-book